CHILDREN *of* GRASS

CHILDREN
of
GRASS

A PORTRAIT
OF AMERICAN POETRY

B.A. VAN SISE
FOREWORD BY MARY-LOUISE PARKER

For Copyright and Credit lines for individual Works of Poetry
included in this anthology, see back of book.

Publisher gratefully acknowledges the following for permission to reprint:
Persea Books for the use of "Shave" by Gabrielle Calvocoressi from *Rocket Fantastic*. Copyright © 2017 by Gabrielle Calvocoressi. Reprinted with the permission of Persea Books, New York. All rights reserved; and W.W. Norton & Co for permission to reprint "Deep Lane(When I'm down on my knees)" from *Deep Lane: Poems* by Mark Doty. Copyright © 2015 by Mark Doty. Used by permission of W.W. Norton & Co.; "Demeter's Prayers to Hades" from *Mother Love* by Rita Dove. Copyright © 1995 by Rita Dove. Used by permission of W.W. Norton & Co.; from *Heating & Cooling: 52 Micro-Memoirs* by Beth Ann Fennelly. Copyright © 2017 by Beth Ann Fennelly. Used by permission of W.W. Norton & Co.; "Cancer Winter" from *Winter Numbers* by Marilyn Hacker. Copyright © 1994 by Marilyn Hacker. Used by permission of the author and W.W. Norton & Co.; "Drowning Horses". Copyright © 1983 by Joy Harjo from *She Had Some Horses* by Joy Harjo. Used by permission of the author and W.W. Norton & Company.

Due to space limitations, for all other Copyright and Credit listings for Individual Works of Poetry included in this anthology, see back of the book.

First Hardcover Edition
Printed and bound in China

Published with support from the University of Arizona Poetry Center

Cover and Interior Design: Jordan Wannemacher
Author Photo: Jolene Lupo & Geoffrey Berliner/Penumbra Foundation.

ISBN: 978-1-943-156-82-5

www.schaffnerpress.com

Front cover image: Mark Doty
Back cover image: Rita Dove

for Sarah, some times

FOREWORD

Mary-Louise Parker

CHILDREN OF GRASS IS A REVELATORY testament to the legacy left by Walt Whitman. With his rejection of hierarchy and tradition; Whitman's was the actual dream of an inclusive America, a universe with 'the palpable and impalpable in its place.' "Leaves of Grass" remains the clearest advocate for humankind in the English language, and the ideals of political, artistic and personal freedom were never expressed with such thrilling humanity or received so enthusiastically. Whitman had the temerity to speak up joyously, and belted out that anthem to his own downbeat, proving that poetry doesn't have to rhyme. That the following pairings of photographs with American poetry is a monument to Whitman by his descendant, the photographer B. A. Van Sise, turns the project into a mythic event, recalling the words of Whitman himself: *I announce greater offspring, orators, days, and then depart.*

Van Sise has indeed created something monumental. All of the photographs stand alone in their mastery, and are in keeping with great poems in that they deserve revisiting. At first glance, the portrait of Anis Mojgani revealed an unearthed specter, but alongside his poem, 'Fossil', it grew dreamlike, and my empathy sparked. Mojgani's gorgeous poem inspired the title page photograph, and I saw all the players of that poem in his face: *a bat, not yet born, the father, still as snow, fear in his body*: and *wild creatures.....pulled into the world's dusty light*.

These pairings speak to each other without polluting the mystery of either, or revoking the license to interpret that poetry gives us. Some feel less like obvious marriages than soul mates meeting their other, but finding your version of the poem in the photograph is as satisfying as when a piece of the verse is reified in the image. The incredible Danez Smith appears *scorched & dangerous & glowing*, but the intimacy of the poem is preserved by Van Sise's choice to depict the poet's sense of isolation. The beseeching quality in the verse is present in their face; Smith appears ready to strike a deal with any known God, which reminds us that that the poem is not a conversation. Van Sise's frames reveal a deep reader of poetry, but he manages to not make himself the star of the

photos, nor to suck the blood out of his subjects. Some are at home in front of the camera, and if a few feel a little less free, it reads more as dignity than reluctance, and Van Sise uses that. It also might not be coincidence that so many poets here are armed with a light source. The phenomenal Matthew Zapruder is caught holding his lamp, the one he loves *so much I have taken it everywhere, despite the broken switch*. Van Sise places the poet folded in the midst of speeding traffic, reminding us of the risk inherent in poetry, and Zapruder's outsider's gaze promises answers to everything he realizes no one may ever stop to hear. He stands undaunted but not unharmed, inventing his own holiday while the world careens past.

For me, the right poem is the surest method of time travel into the present moment. Recognizing that someone else was also left stranded in front of a feeling that couldn't be wrestled into normal language is the best way to admit that I'm not completely alone. Reading Denis Johnson's 'terror of being just one person, one chance, one set of days' is shocking not only because I get what he means, it's the shock of realizing *that's what I mean*.

Poems are the product of abnormal thinking. They are the weirdos at the literary banquet, because they can be difficult, and uncompromising; they don't offer an easy in or a proper hello. 'The whole night sky went bad in the knees,' begins James Galvin's 'Putting down the night.' You aren't offered a context and you don't need it. You read the poem and recognize your own sky within it. I don't have to know what he means to know what he means. *The palpable and the impalpable in its place.*

If you think you don't enjoy poetry, I will offer that you haven't met your poem yet, but wherever you stand on poetry, you can still appreciate this book. My son says photography is wonderful because photos can show you what words can't, and these images will leave you with much to discover. You can obviously experience them separately, but when I held an image alongside its verse, and made a meal of moving from one to the other, I caught the genius of this experiment, one I will declare worth calling in sick and devoting a day to. Take to your bed with a bottle of anything wet and someone who loves poetry, or who can at least relish being read to, and you may have the best Valentine's Day ever. Surely there exists a terrific word for what this book achieves, but f*&%ing awesome is all I can land on, amidst dreaming of future volumes that pair truth and beauty with more of the same. Either way, Whitman is surely found amidst these pages, where *You may hardly know who I am, but I shall be good health to you nevertheless, and filter and fiber your blood.*

ANIS MOJGANI

Fossil

The stampede came rushing over the red hills, their bodies kicking the dust into the air. Father had to scoop me out of their path. He stood still as snow once the falling stops and the beasts just moved their way around him all thunder and muscle. I could hear his heart moving as fast as the animals running past. I could hear the fear in his body, how he had no idea what to do, only knew to hold me close, nothing given to him but an overturned skull with a candle, lit and turned south to drip into and then set inside. Nothing given but a small little light used to move across the stone walls only revealing what is right in front of the flame. He held me in both hands like that skull—skull made into lamp by an upside down motion, a cradle to carry what had carried him forth out of whatever soft world we come from and into this one, that the unknowing which surrounded he and my mother like the dark trees on both sides of the bank might also be the lantern hung upon the bow, not knowing what might lie outside its small circumference of light, only that the water moves us in this direction, from the source to the mouth. The animals passed. Their echoes hung in the air like moss. I was small as the skull of a bumblebee bat. Less than half an inch. My father placed me in his breast pocket. This actually happened. I was small enough for him to hold me upon his heart. He stood there with a bat skull pressed to his body until the beating in his chest became smooth as the state line of a distant state. I was a bat not yet born held to the heart of a man not yet father. This actually happened. It is from out of the shadow of the songs of wild creatures that we are all pulled and placed into this world's dusty light.

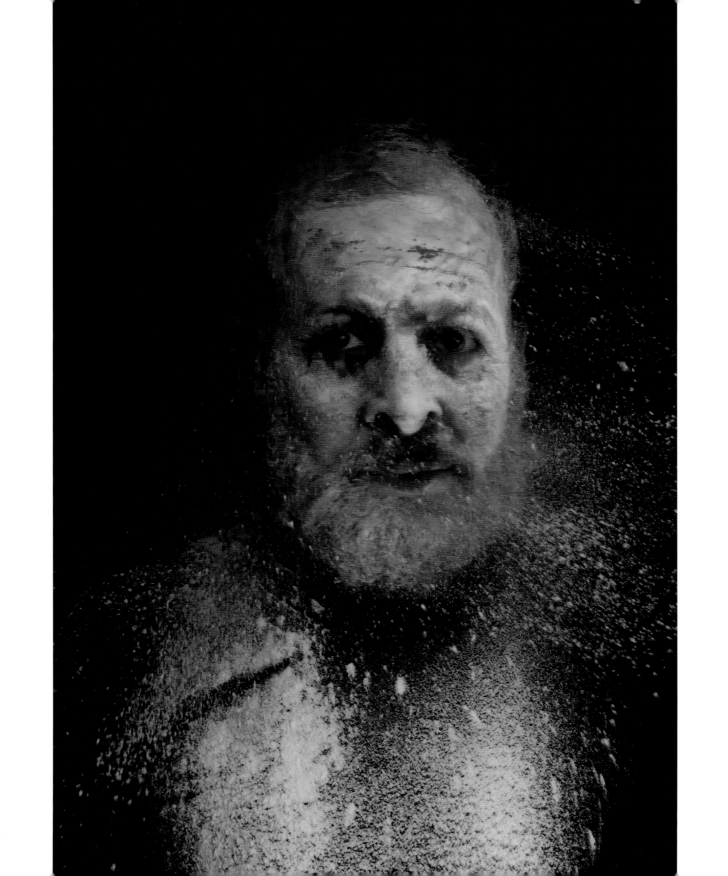

NIKKI GIOVANNI

Allowables

I killed a spider
Not a murderous brown recluse
Nor even a black widow
And if the truth were told this
Was only a small
Sort of papery spider
Who should have run
When I picked up the book
But she didn't
And she scared me
And I smashed her

I don't think
I'm allowed

To kill something
Because I am
Frightened

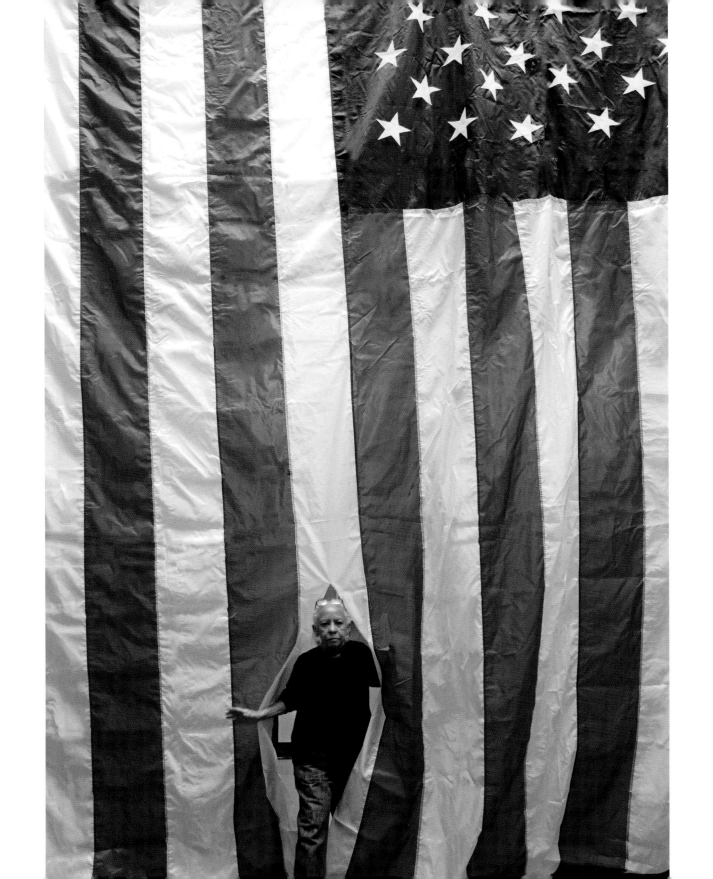

GREGORY PARDLO

from *The Clinamen Improvisations*
Epicurus: The honor paid to a wise man is itself a great good for those who honor him.

Sam Cooke reminds you how *Ol' Man River just keeps rolling*
and you begin to wonder what makes a river tick so you go sit
on Union Street Bridge to study the unruffled Gowanus Canal
with its tempting reflections and perfect your knack for reading
water's Om through the clockwork of the air and you think it's like
you which is not much of a river but wise enough water to hush your
regrets for the bloated casualties of your myriad indiscretions since
the first African was made to scoop the marsh to irrigate Dutch farms
until this moment when you see you are that African and you are
the Gowanus just as you are the baby whale lost and barging so far
along the canal you are blessed now and breaking and love this
one the Daily News will name Sludgy whom you will birth still
upon your bay at Red Hook after the sewer spills a glum baptismal
across his fontanel and children will stand around and amen
the Coast Guard atop the fly-flecked carcass preaching that wisdom
bends light into the eye of the whale where if you look close children
you'll find the water bears a flower, and the flower bears your name

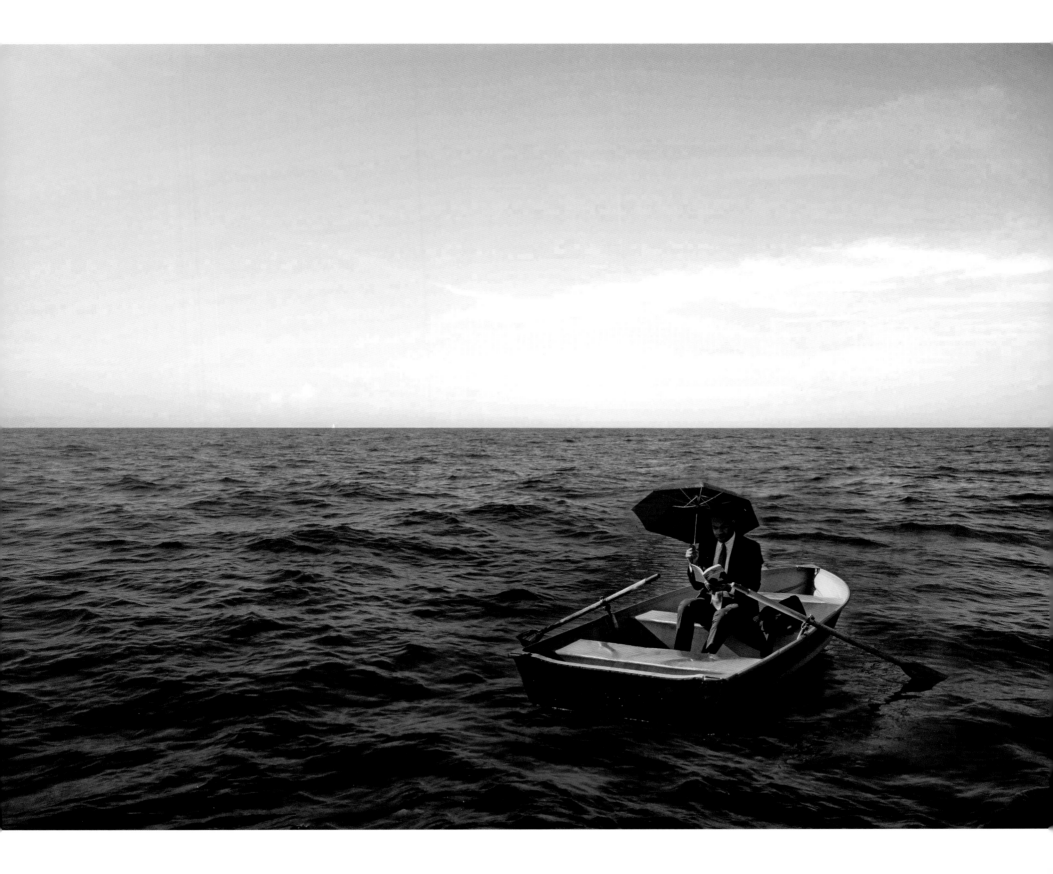

RITA DOVE

Demeter's Prayer to Hades

This alone is what I wish for you: knowledge.
To understand each desire has an edge,
to know we are responsible for the lives
we change. No faith comes without cost,
no one believes without dying.
Now for the first time
I see clearly the trail you planted,
what ground opened to waste,
though you dreamed a wealth
of flowers.

 There are no curses—only mirrors
held up to the souls of gods and mortals.
And so I give up this fate, too.
Believe in yourself,
go ahead— see where it gets you.

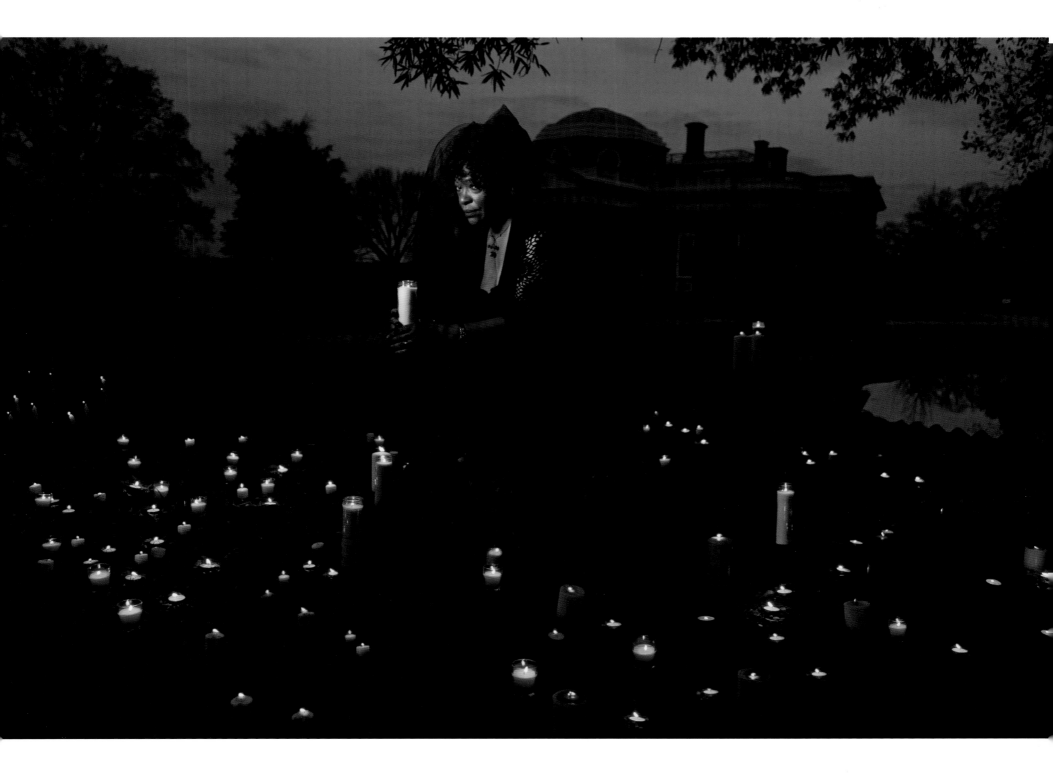

DANA GIOIA

Becoming a Redwood

Stand in a field long enough, and the sounds
start up again. The crickets, the invisible
toad who claims that change is possible,

And all the other life too small to name.
First one, then another, until innumerable
they merge into the single voice of a summer hill.

Yes, it's hard to stand still, hour after hour,
fixed as a fencepost, hearing the steers
snort in the dark pasture, smelling the manure.

And paralyzed by the mystery of how a stone
can bear to be a stone, the pain
the grass endures breaking through the earth's crust.

Unimaginable the redwoods on the far hill,
rooted for centuries, the living wood grown tall
and thickened with a hundred thousand days of light.

The old windmill creaks in perfect time
to the wind shaking the miles of pasture grass,
and the last farmhouse light goes off.

Something moves nearby. Coyotes hunt
these hills and packs of feral dogs.
But standing here at night accepts all that.

You are your own pale shadow in the quarter moon,
moving more slowly than the crippled stars,
part of the moonlight as the moonlight falls,

Part of the grass that answers the wind,
part of the midnight's watchfulness that knows
there is no silence but when danger comes.

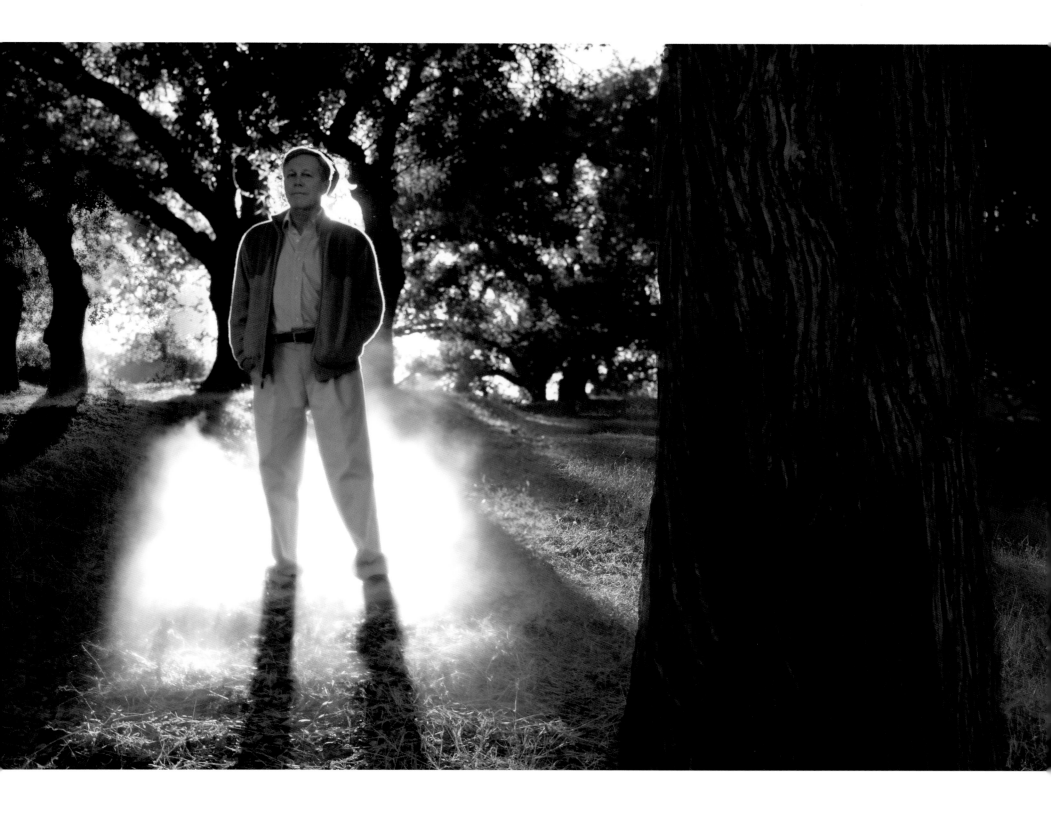

ADRIENNE SU

Escape from the Old Country

I never had to make one,
no sickening weeks by ocean,

no waiting for the aerogrammes
that gradually ceased to come.

Spent the babysitting money
on novels, shoes, and movies,

yet the neighborhood stayed empty.
It had nothing to do with a journey

not undertaken, not with dialect,
nor with a land that waited

to be rediscovered, then rejected.
As acid rain collected

above the suburban hills, I tried
to imagine being nothing, tried

to be able to claim, "I have
no culture," and be believed.

Yet the land occupies the person
even as the semblance of freedom

invites a kind of recklessness.
Tradition, unobserved, unasked,

hangs on tight; ancestors roam
into reverie, interfering at the most

awkward moments, first flirtations,
in doorways and dressing rooms—

But of course. Here in America,
no one escapes. In the end, each traveler

returns to the town where, everyone
knew, she hadn't even been born.

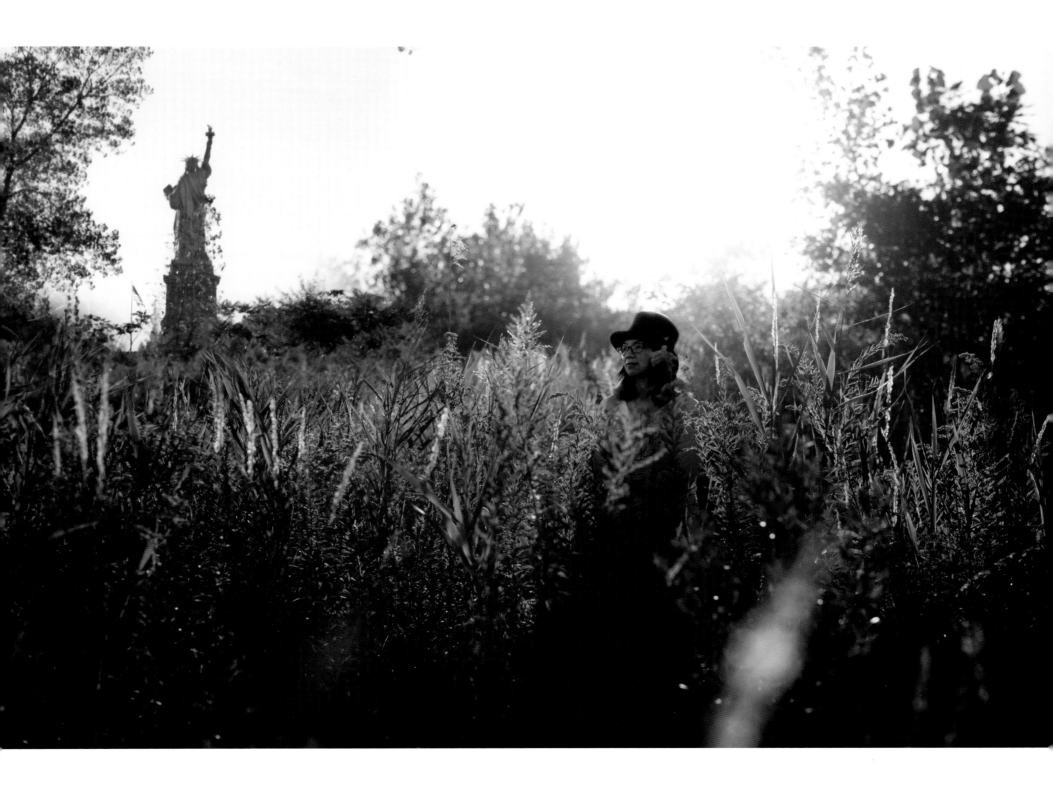

KAVEH AKBAR

Some Boys Aren't Born They Bubble

some boys aren't born they bubble
up from earth's crust land safely around
kitchen tables green globes of fruit already

in their mouths when they find themselves crying
they stop crying these boys moan
more than other boys they do as desire

demands when they dance their bodies plunge
into space and recover the music stays
in their breastbones they sing songs

about storms they dry their shoes on porches
these boys are so cold their pilot lights never light
they buy the best heat money can buy blue flames

swamp smoke they are desperate
to lick and be licked sometimes one will eat
all the food in a house or break every bone

in his jaw sometimes one will disappear into himself
like a ram charging a mirror when this happens
they all feel it afterwards the others dream

of rain their pupils boil they light black candles
and pray the only prayer they know *oh lord*
spare this body set fire to another

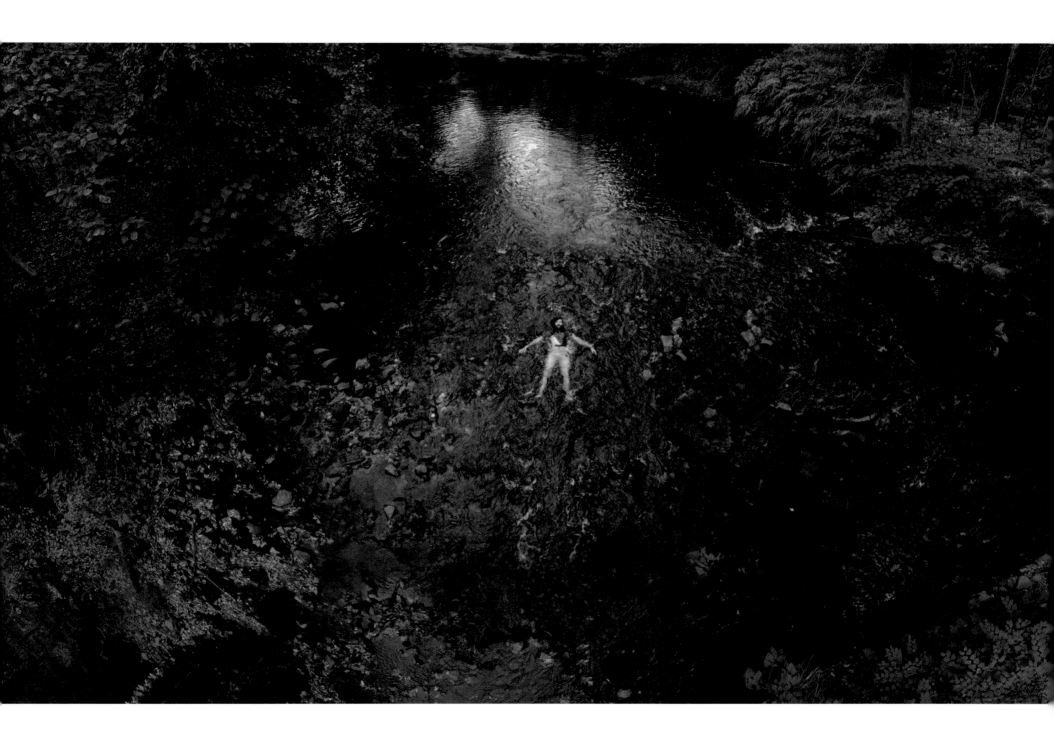

ROBERT HASS

The Yellow Bicycle

The woman I love is greedy,
but she refuses greed.
She walks so straightly.
When I ask her what she wants,
she says, "A yellow bicycle."

Sun, sunflower,
coltsfoot on the roadside,
a goldfinch, the sign
that says Yield, her hair,
cat's eyes, his hunger,
and a yellow bicycle.

Once, when they had made love in the middle of the night and it was very sweet, they decided they were hungry, so they got up, got dressed, and drove downtown to an all-night donut shop.
Chicano kids lounged outside, a few drunks, and one black man, selling dope. Just at the entrance there was an ol woman in a thin floral print dress. She was barefoot. Her face was covered with sores and dry peeling skin. The sores looked like raisins and her skin was the dry yellow of a parchment lampshade ravaged by light and tossed away. They thought she must have been hungry and, coming out with a white paper bag full of hot rolls, they stopped to offer her one. She looked at them out of her small eyes, bewildered, and shook her head for a little while and said, very kindly, "no."

Her song to the yellow bicycle:
The boats on the bay
have nothing on you,
my swan, my sleek one!

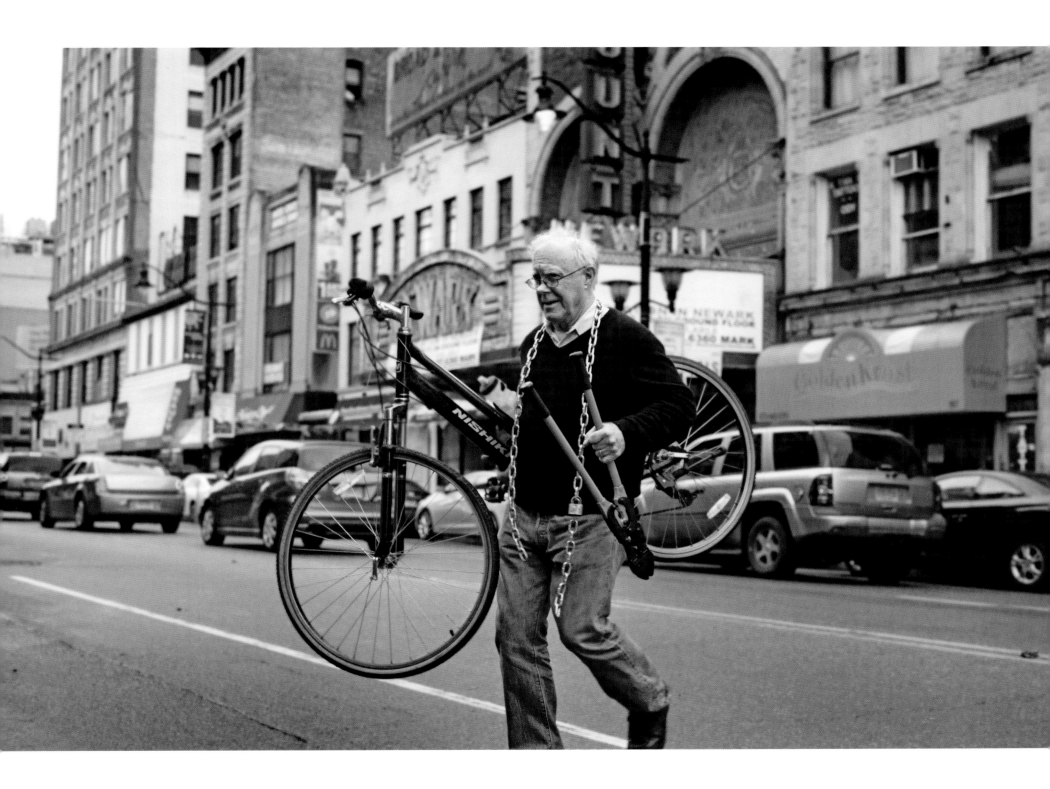

ROBERT PINSKY

The Wave
(Virgil, *Georgics* III: 237-244)

As when far off in the middle of the ocean
A breast-shaped curve of wave begins to whiten
And rise above the surface, then rolling on
Gathers and gathers until it reaches land
Huge as a mountain and crashes among the rocks
With a prodigious roar, and what was deep
Comes churning up from the bottom in mighty swirls
Of sunken sand and living things and water-

So in the springtime every race of people
And all the creatures on earth or in the water,
Wild animals and flocks and all the birds
In all their painted colors,
 all rush to charge
Into the fire that burns them: love moves them all.

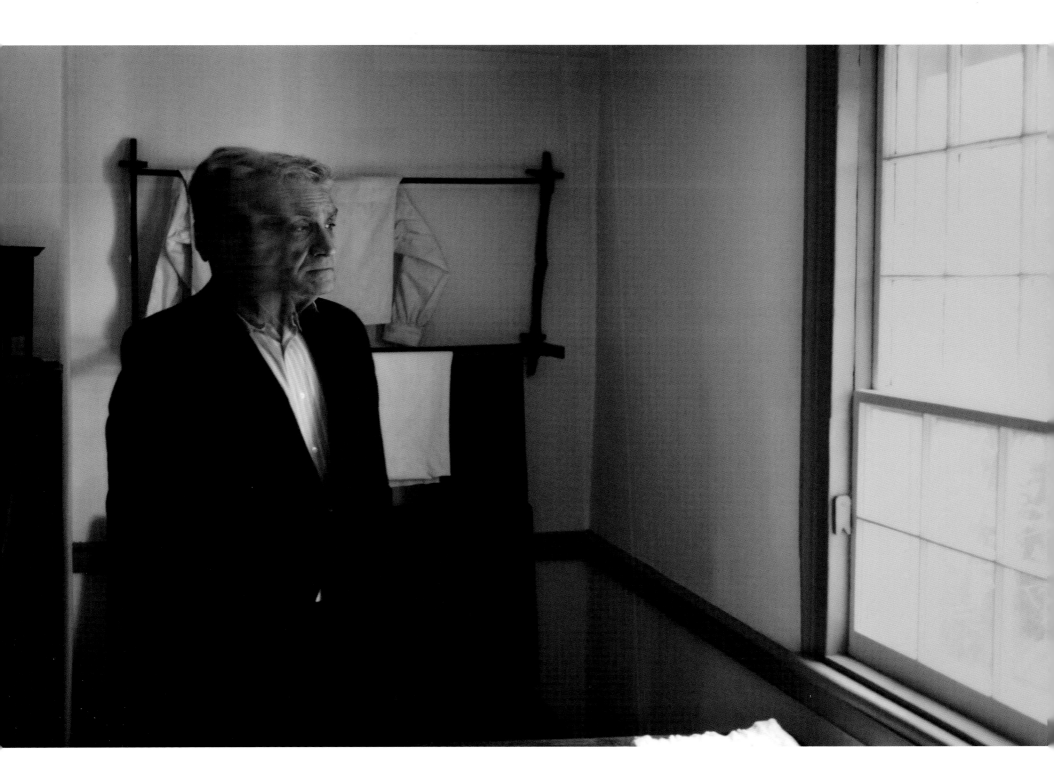

DORIANNE LAUX

As It Is

The man I love hates technology, hates
that he's forced to use it: telephones
and microfilm, air conditioning,
car radios and the occasional fax.
He wishes he lived in the old world,
sitting on a stump carving a clothespin
or a spoon. He wants to go back, slip
like lint into his great-great-grandfather's
pocket, reborn as a pilgrim, a peasant,
a dirt farmer hoeing his uneven rows.
He walks when he can, through the hills
behind his house, his dogs panting beside him
like small steam engines. He's delighted
by the sun's slow and simple
descent, the complicated machinery
of his own body. I would have loved him
in any era, in any dark age; I would take him
into the twilight and unwind him, slide
my fingers through his hair and pull him
to his knees. As it is, this afternoon, late
in the twentieth century, I sit on a chair
in the kitchen with my keys in my lap, pressing
the black button on the answering machine
over and over, listening to his message,
his voice strung along the wires outside my window
where the birds balance themselves
and stare off into the trees, thinking
even in the farthest future, in the most
distant universe, I would have recognized
this voice, refracted, as it would be, like light
from some small, uncharted star.

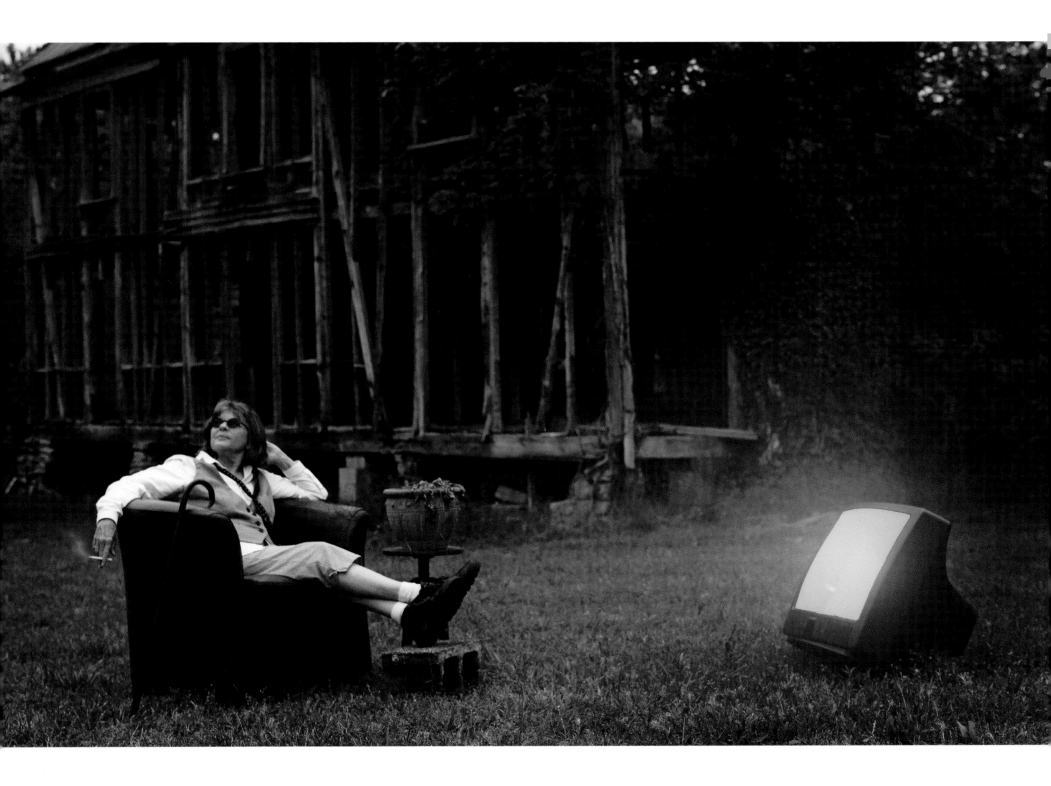

KIM ADDONIZIO

First Poem For You

I like to touch your tattoos in complete
darkness, when I can't see them. I'm sure of
where they are, know by heart the neat
lines of lightning pulsing just above
your nipple, can find, as if by instinct, the blue
swirls of water on your shoulder where a serpent
twists, facing a dragon. When I pull you
to me, taking you until we're spent
and quiet on the sheets, I love to kiss
the pictures in your skin. They'll last until
you're seared to ashes; whatever persists
or turns to pain between us, they will still
be there. Such permanence is terrifying.
So I touch them in the dark; but touch them, trying.

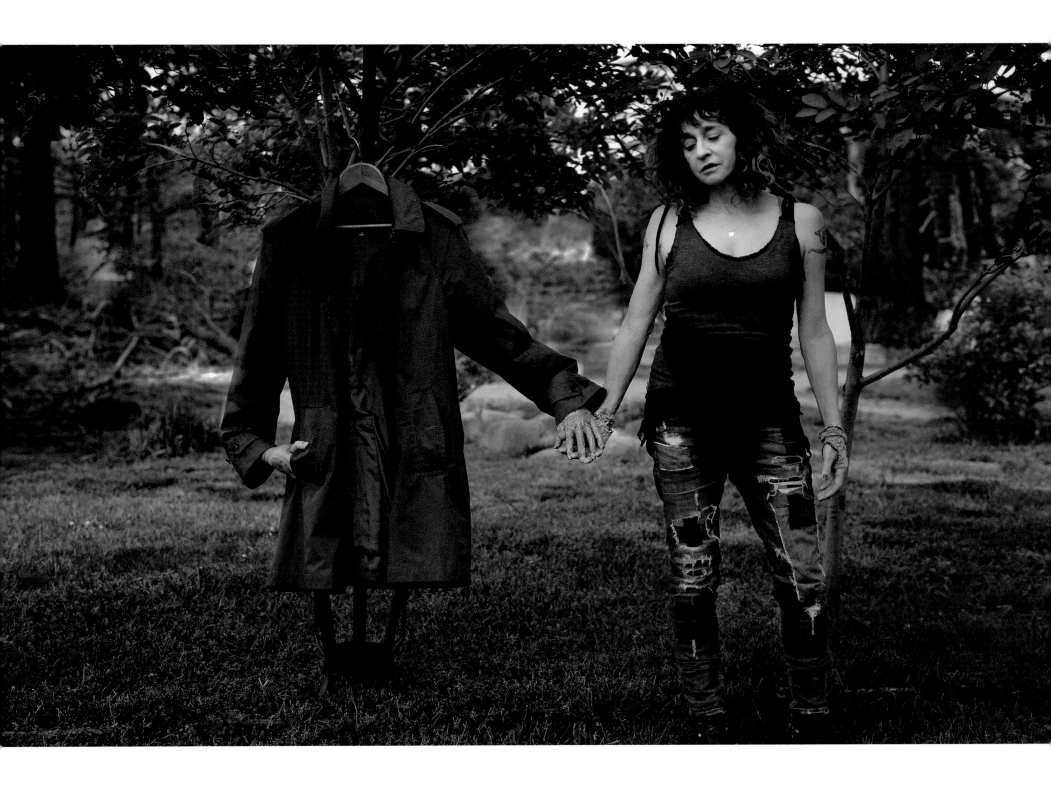

X.J. KENNEDY

from *Famous Poems, Abbreviated*

Once upon a midnight dreary,
Blue and lonesome, missed my dearie.
Would I find her? Any hope?
Quoth the raven six times, "Nope."

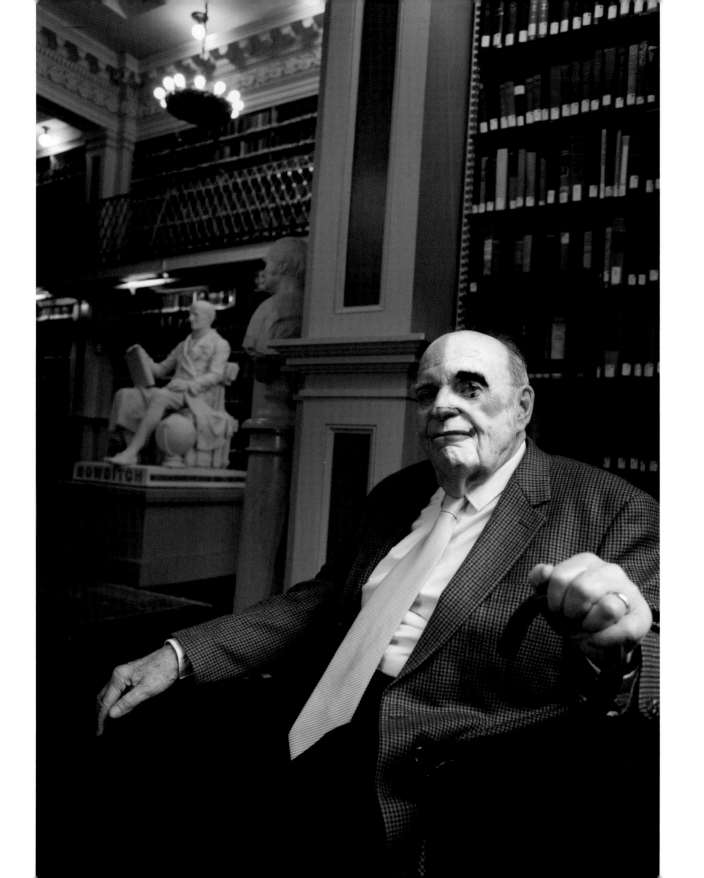

JEFFREY MCDANIEL

The Quiet World

In an effort to get people to look
into each other's eyes more,
and also to appease the mutes,
the government has decided
to allot each person exactly one hundred
and sixty-seven words, per day.

When the phone rings, I put it to my ear
without saying hello. In the restaurant
I point at chicken noodle soup.
I am adjusting well to the new way.

Late at night, I call my long distance lover,
proudly say *I only used fifty-nine today.*
I saved the rest for you.

When she doesn't respond,
I know she's used up all her words,
so I slowly whisper *I love you*
thirty-two and a third times.
After that, we just sit on the line
and listen to each other breathe.

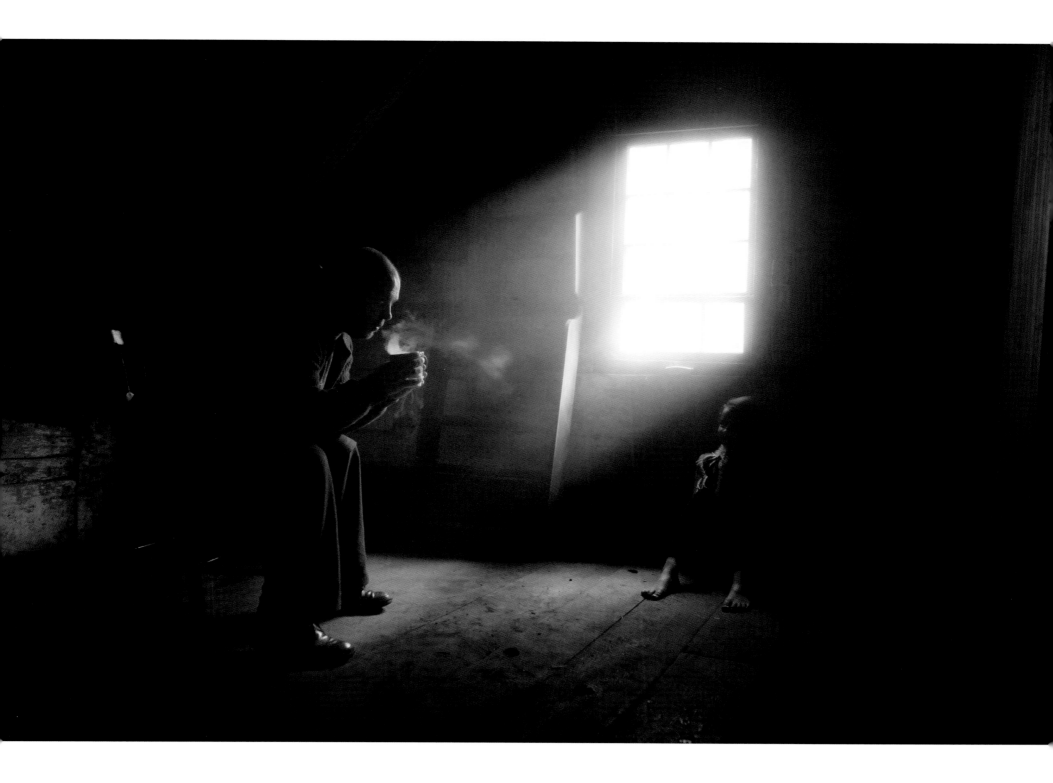

SAM SAX

When Researching Public Sex Theatres For A Poem

you know you have to pay, right?
 the marquee does its neon work to draw you
 but your wallet will be punished.

the big man sits in his tiny booth with his big hands
 you wonder if he finds you disgusting, or sees you
 place the bill right in his palm. feel meat

through the currency. fantasize he might follow you in,
 leave your eyes in his mouth. what is a poem worth, anyway?
 ten dollars at the door? the long staircase? the soiled

cloth seats? who uses cloth seats anymore, anyway?
 you read they hold disease better than mosquitoes.
 you feel the swarm beneath you as you sit.

each tiny needle sucking you down. it is dark
 as you imagined. but you do not do what you imagined
 you would do. your body does not transform

into something with more limbs. prehensile and guttural.
 you sit. hands decorative silk napkins folded in pockets.
 the whole of your skin shrinking way from its lineage.

that accordion history opening all its doors into the dark.
 imagine the actors dead now, forever blazing in celluloid
 before the swarms of us, forced into the same positions

over and over, the desperate cocaine buzzing through
 the screen. the same angry hives, the overdubbed screams.
 in the pause between films, you wonder again,

the cost of a poem. is it the man wearing a dark suit
 beside you? his face a candle of legs? his wet and demanding
 skin? the next film begins ... and you reach out for him.

the mosquito's feeding the blood forward into your hands.
 your hands, outstretched as though you'd expect him to save
 you. but he pulls away. he fades into the dark. then,

when you open your mouth one strange voice stumbles out
 after another. pandemic of hair yawns down your back, a thin
 tail gasps out from between your hind legs. so you walk

down the long staircase. your body transforming into something
 so much smaller. the big man's hands now are five stories wide.
 in the cab ride home, you laugh at how you tried to speak

a dying language. how naive and brave you were.
 how ludicrous you believed you might find something holy
 in sweat, a new way to talk about perversion or release

or the genealogy of desire. you do not tell anyone you went. so tiny
 you could climb inside a stranger's pocket. and you want to.
 and you paid to. ugly swarm of cloth still folded in the blood.

isn't it funny how you once believed nothing
in this whole world could disgust you?

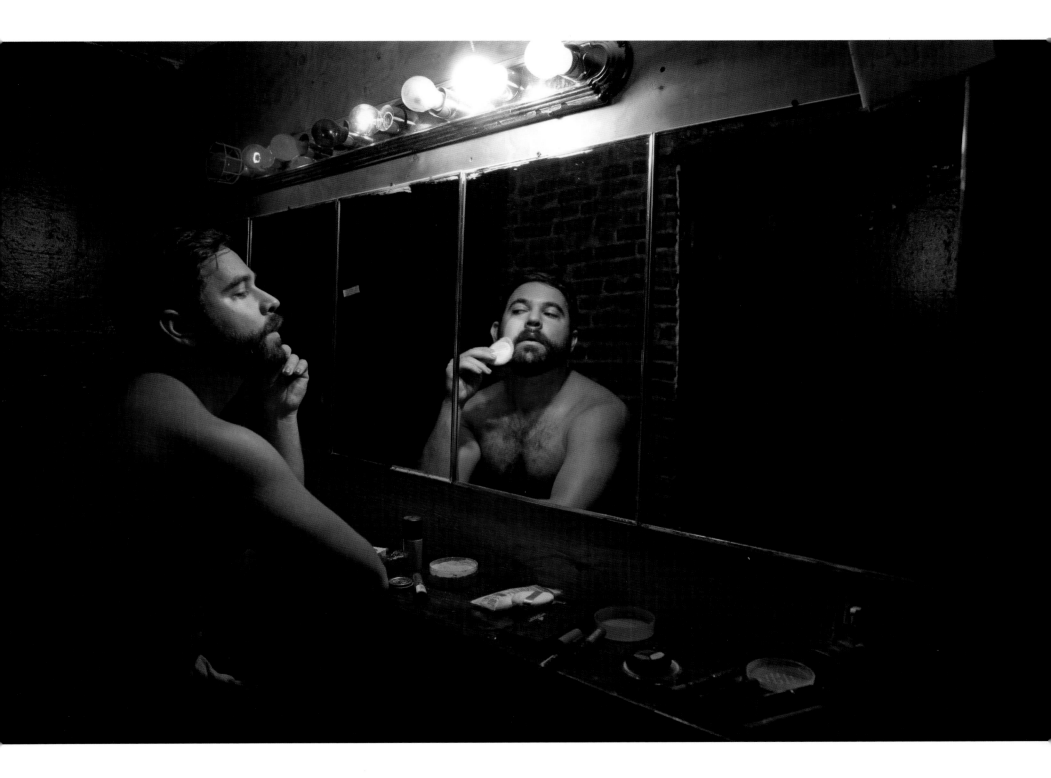

AIMEE NEZHUKUMATATHIL

Dear Amy Nehzooukammyatootill,

(a found poem, composed entirely of e-mails from various high school students)

If I were to ask you a question about your book
and sum it up into one word it would be, 'Why?'
I think I like Walt Whitman better than you. I just don't
get literature, but for a fast hour and a half read, your book

takes the cake. I like how you organized the lines
in that one poem to represent a growing twisting bonsai tree.
Are you going to get a rude reaction when you meet
that one guy in that one poem? I guess you never know.

You are very young to be a poet. I also like how your poems take
up an entire page (it makes our reading assignment go faster).
In class we spend so much time dissecting your poems
and then deeply analyzing them. I think I like Walt Whitman

better than you, but don't take offense—you are very good too!
You are young, You are young and pure and really just want
to have a good time. Thank you we have taken a debate
and you are a far better poet than Walt Whitman. And I loved

how your poems were easy to read and understand. Hello
my name is Alicia. We read you book and I just loved it.
We also read Walt Whitman's 'Leaves of Grass.' There
was no competition there. I liked your book a whole lot better.

It was an easy read. But poetry is not my favorite type
of literature. Sometimes I am offered drinks and guys
try to talk to me but I too just brush it off and keep dancing.
Every once and a while the creepy mean guys try to offer you

things and then they say something. What would you do?
Lastly, I was wondering if you ever wrote a poem that really
didn't have a deeper meaning but everyone still tried
to give it one anyways? Walt Whitman is better than you.

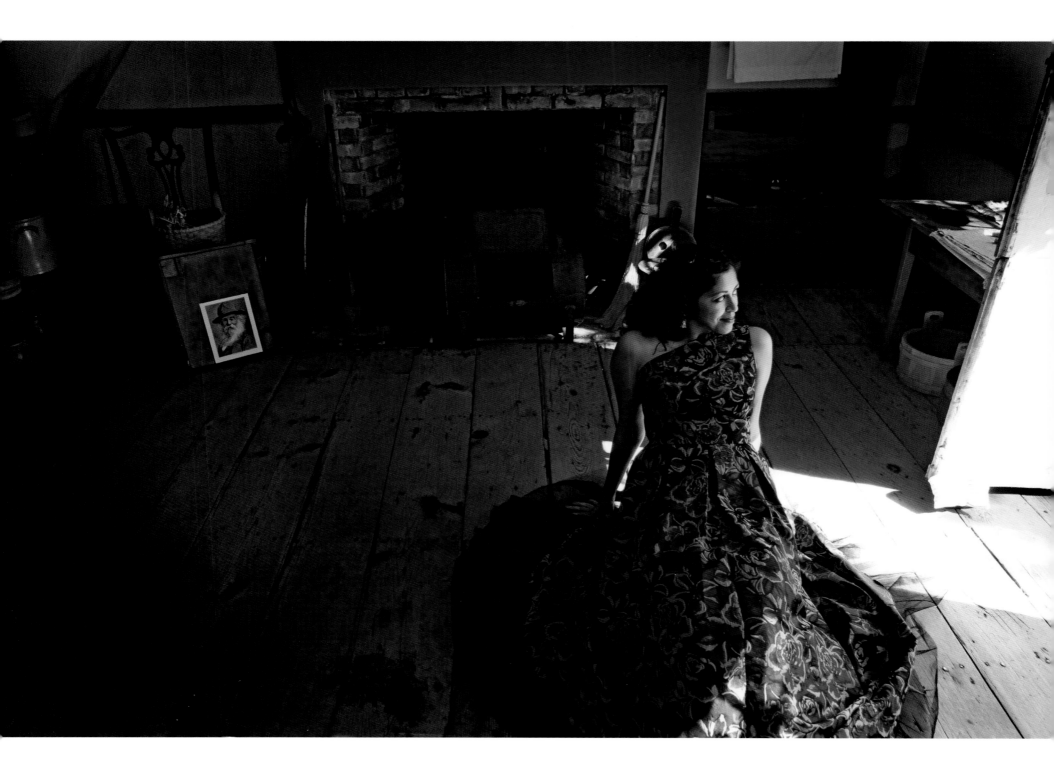

DAPHNE GOTTLIEB

From sexy balaclava

Revolution
is not pretty

but I don't care
about looks.
Set the dumpster

on fire. Break
the windows.
Don't kiss me

like they do
in the movies.
Kiss me

like they do
on the emergency
broadcast system.

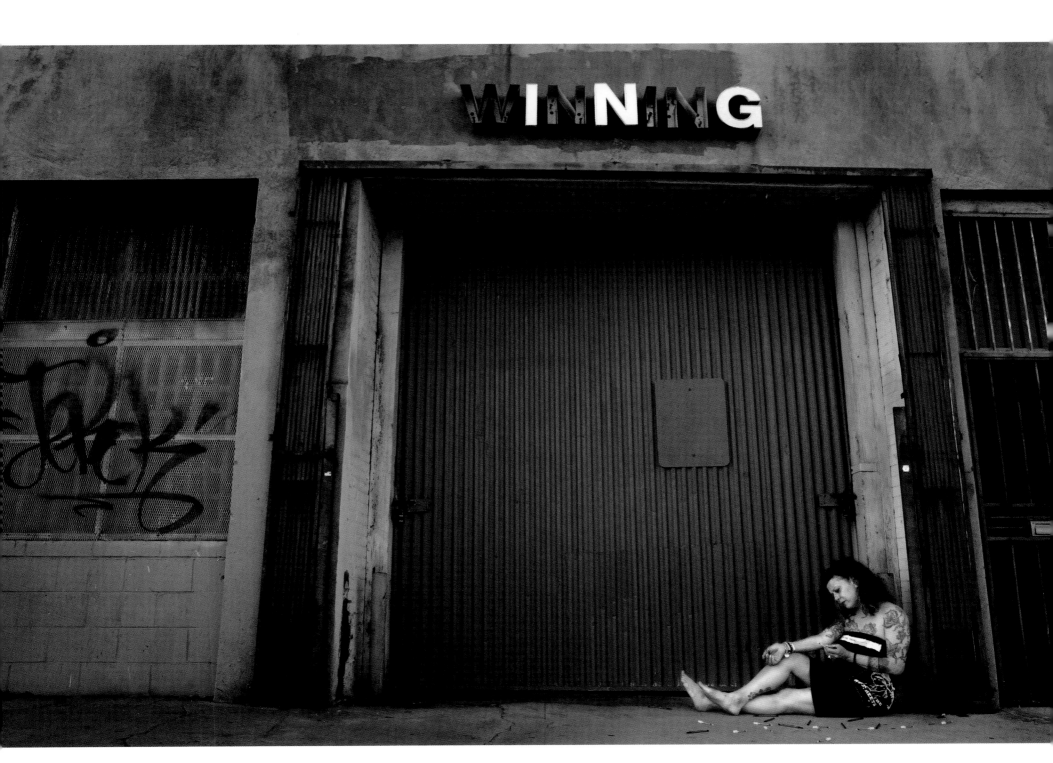

LUIS AMBROGGIO

Identidad Humana

Veo en tu cuerpo
el universo de una historia,
la geografía tallada
de muchas conquistas y derrotas;
en la gloria de tus ojos,
las arrugas con su siembra,
las sonrisas y lágrimas,
veo el horizonte cotidiano
del amor y de las pérdidas,
la dulzura amarga del éxito,
la dolorosa esperanza del fracaso.

Veo en tu cuerpo
-que camina la naturaleza,
la ciudad, la montaña,
el campo de la vidael
paso de la muerte
y el aliento de tu pupila,
hombre y mujer, joven y viejo,
esencia de multitudes,
gris anónimo y con el grito
de un nombre cierto.

Te veo en un cuerpo que abarca
simultáneo tiempo y eternidad,
al amanecer, al crepúsculo, sol, lunas llenas
y sus extensiones de luz, oscuridad
en una sangre inquieta y suave,
corazon liquido sin fronteras.

Veo en tu cuerpo
la raza y la ausencia de razas
exhalando sin indulgencia
la blasfemia de la discriminación
y su bienaventurada condena.

Eres todo, toda, en uno,
el mundo asombroso del Yo,
unido y disperso,
en la misma invitación:
conjuro de opuestos
que te definen,
como de definen a mí,
y a cada uno de los otros
existendo en mí y fuera de mí,
en la incesante alma compartida
de la calle abarrotada y sola.

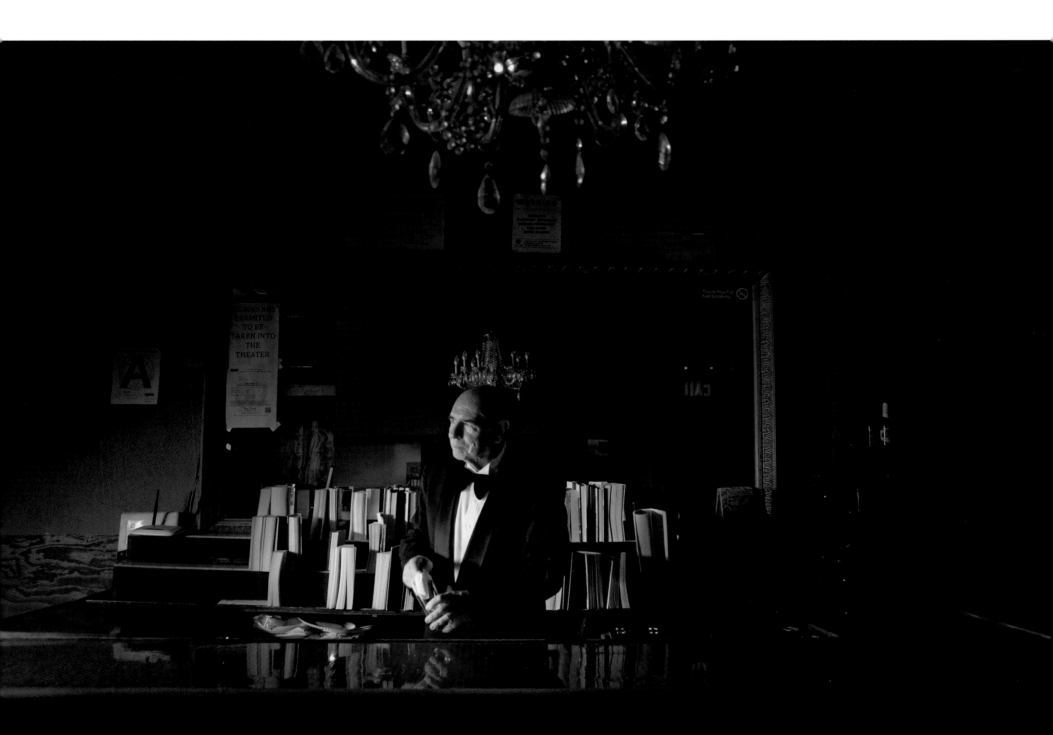

MERCILESS PALACE TO REMEMBER

What is the point of a memory
palace if I hang your portrait in every
room? As one might stuff a man
made of paper with more
paper so that he can burn
longer, I posit that
it helps me remember
the desert, where I hung
a candelabra from the sky
& the weight of it
was nothing to a man
like that. In every room
I kept the tape for measuring
mercilessly his shortcomings
& with luxurious scorn, wondered
how I had ensnared him
there. In a glass jar filled
with knowledge, I keep my children
& they bond me to the mountain
palace, where I can never
live. I am too tall.

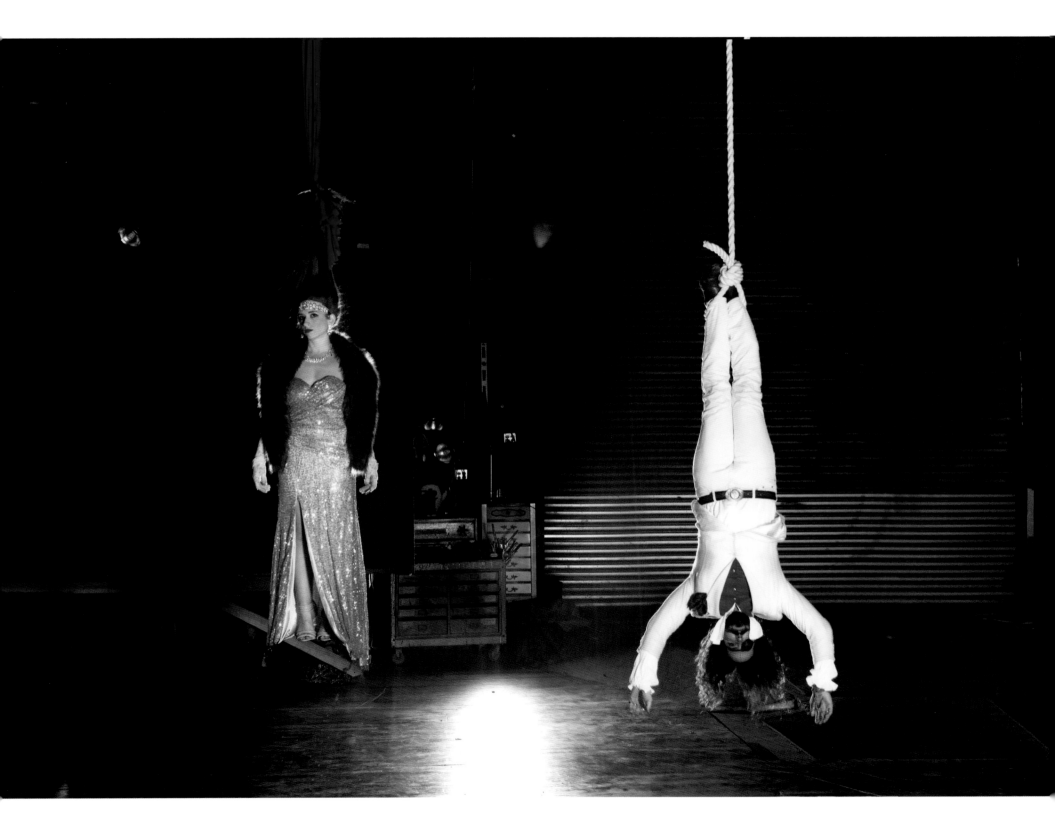

MARTÍN ESPADA

When the Leather is a Whip

At night,
with my wife
sitting on the bed,
I turn from her
to unbuckle
my belt
so she won't see
her father
unbuckling
his belt

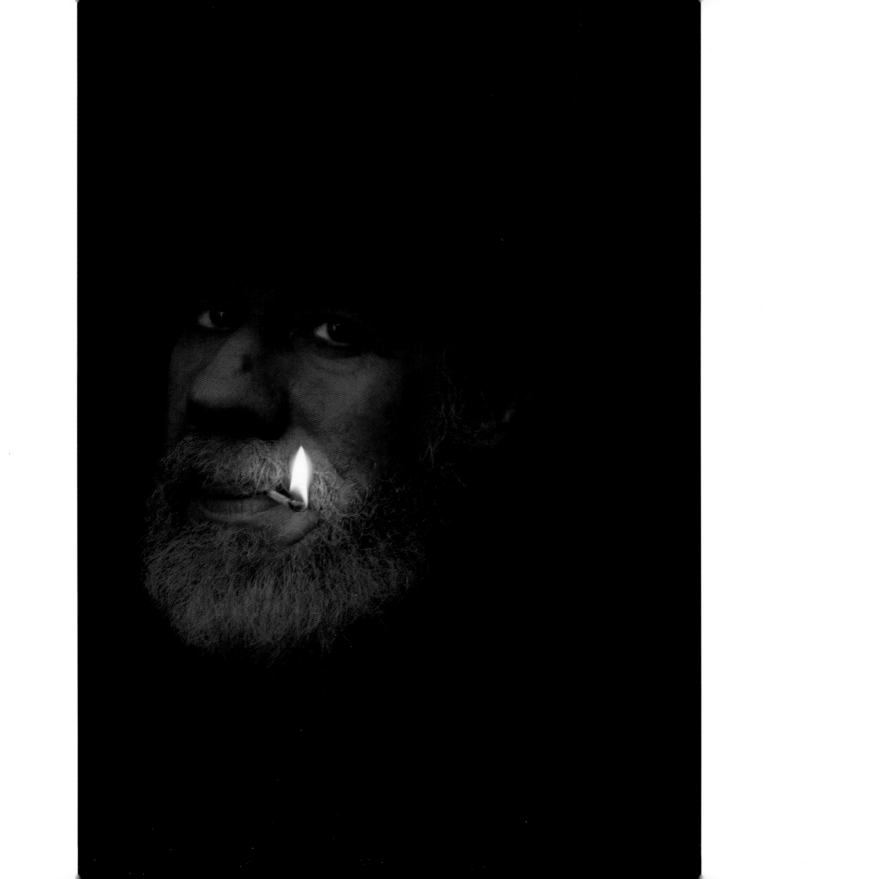

CA CONRAD

from *The Book of Frank*

"this is your
captain" Frank says from the cockpit

"all passengers wishing to bail out
any time during our flight

it
is
too
late

I have shredded the parachutes to confetti
in celebration of our arrival"

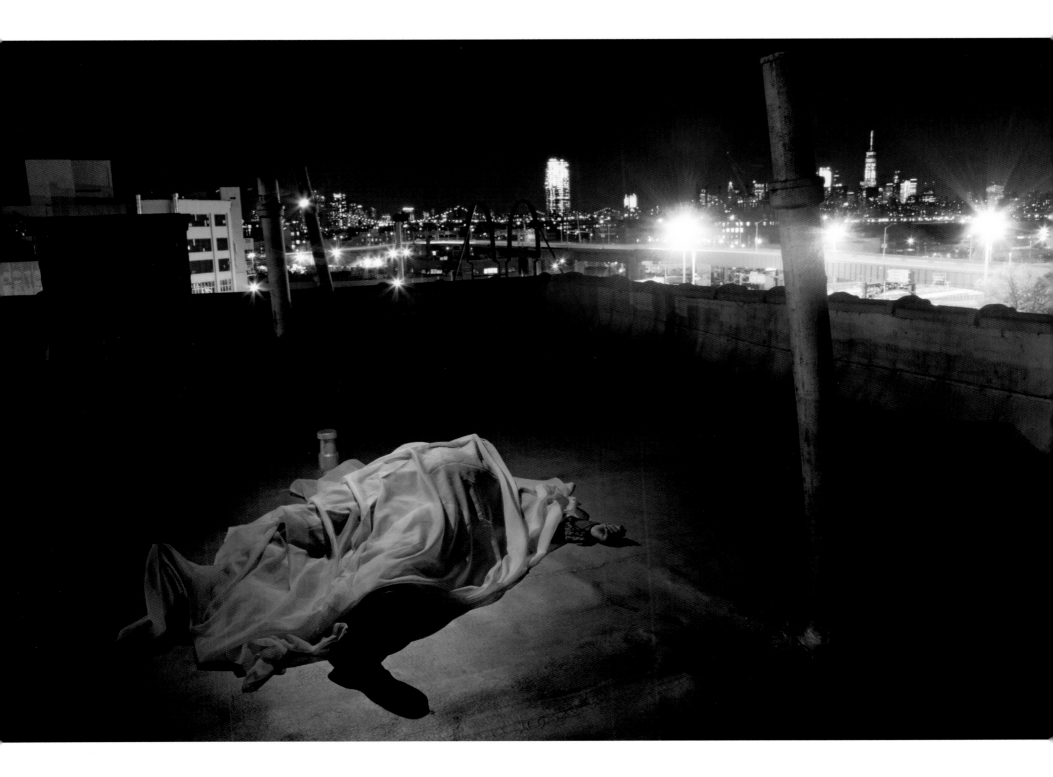

MARILYN HACKER

from *Cancer Winter*

I woke up, and the surgeon said, 'You're cured.'
Strapped to the gurney, in the cotton gown
and pants I was wearing when they slid me down
onto the table, made new straps secure
while I stared at the hydra-headed O.R.
lamp, I took in the tall, confident, brownskinned
man, and the ache I couldn't quite call pain
from where my right breast wasn't anymore
to my armpit. A not-yet-talking head,
I bit dry my lips. What else could he have said?
And then my love was there in a hospital coat;
then my old love, still young and very scared.
Then I, alone, graphed clock hands' asymptote
to noon, when I would be wheeled back upstairs.

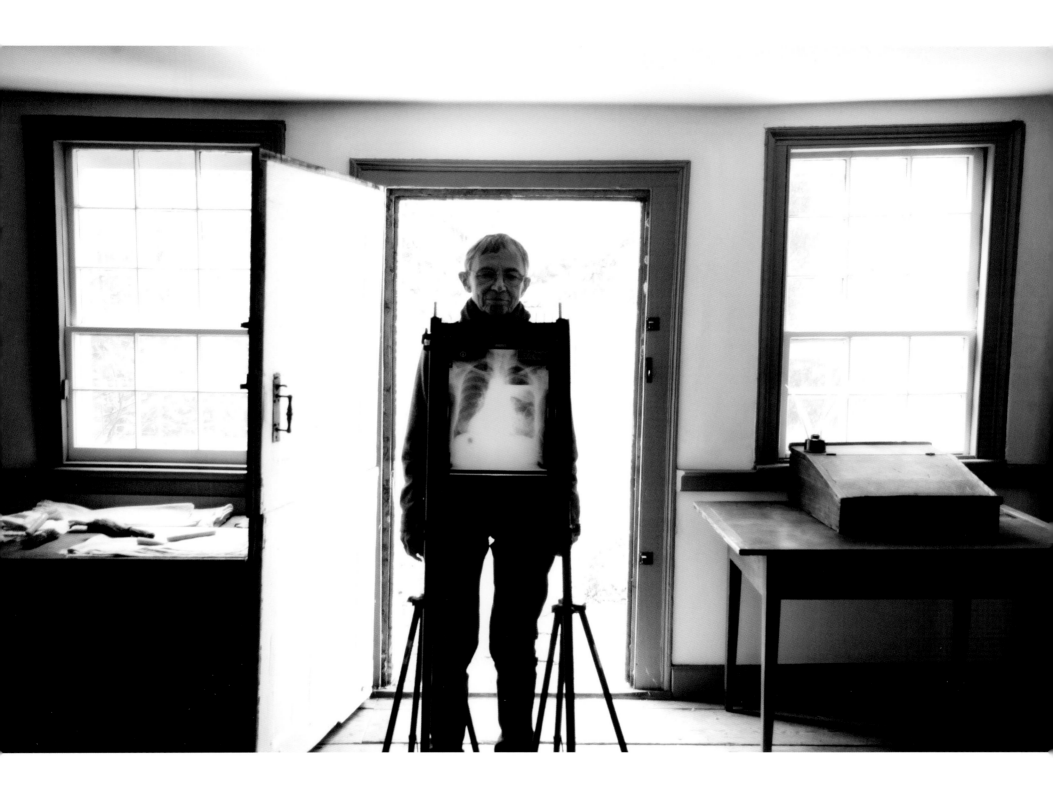

MARK DOTY

Deep Lane

When I'm down on my knees pulling up wild mustard
by the roots before it sets seed, hauling the old ferns
further into the shade, I'm talking to the anvil of darkness:

break-table, slab no blow could dent
rung with the making, and out of that chop and rot
comes the fresh surf of the lupines.

When the shovel slips into white root-flesh,
into the meat coursing with cool water,
when I'm grubbing on my knees, what is the hammer?

Dusky skin of the tuber, naked worms
who write on the soil every letter,
my companion blind, all day we go digging,

harrowing, rooting deep. Spade-plunge
and trowel, sweet turned-down gas flame
slow-charring carbon, out of which sprouts

the wild unsayable.
Beauty's the least of it:
you get ready,

like Deborah, who used to garden in the dark,
hauling out candles and a tall glass of what she said was tea,
and digging and reading and studying in the dirt.

She'd bring a dictionary. If study is prayer, she said, I'm praying.
If you've already gone down to the anvil, if you've rested your face
on that adamant, maybe you're already changed.

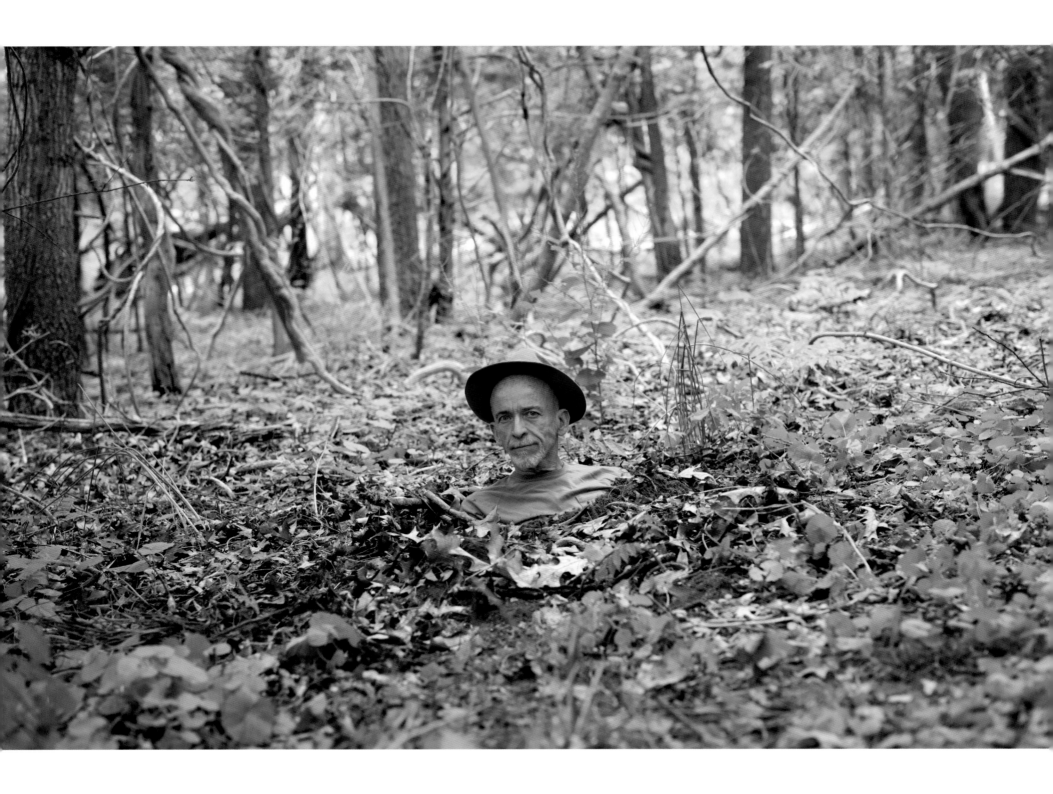

SHARON OLDS

Still Life

At moments almost thinking of her, I was
moving through the still life museum when my mother had her
stroke. I was with the furled leeks, I was
in the domain of the damp which lines
the chestnut hide, of dew on snails,
of the sweated egg, and the newts quick
and the newts gone over on their backs, and the withered
books—she was teaching someone, three
time zones away, to peel and slice
a banana, in the one correct way,
and I was wandering ruins of breakfasts,
broken crusts of a blackberry pie,
the leg of the paper wasp on it done
with a one-thread brush, in oil which had
ground gold in it. She had alerted me,
from the start, to objects, she had cried out
in pain, from their beauty, the way a thing
stood for the value of a spirit, an orange
trailing from its shoulders the stole of its rind,
the further from the tree, the more thinged and dried—
my mother was a place, a crossroads, she held the
banana and lectured like a child professor on its
longitudes and divisible threes,
she raised her hands on her temples, and held them,
and screamed, and fell to her bedroom floor, and I
wandered, calm, among oysters, and walnuts,
mice, aprictos, coins, a golden
smiling skull, even a wild flayed
hare strung up by one foot like a dancer
leaping. There are things I will never know
about love. I strolled, ignorant
of my mother, among the tulips, beetle in its
holy stripes, she lay there and I walked
blind through music.

JAYSON P. SMITH

Untitled

the wound is a matter
of origin. let me rephrase:
i'm whittled down to
function. a final attempt
to be soft. scrubbed
down to the suture
& following tropes.
before was a
muscular greed. this
is a kind of
precision. silence is
not an answer, but grace—
grace is a way for objects to lie.
sometimes i'm sorry & most familiar.
sometimes i fold in the best
condition.

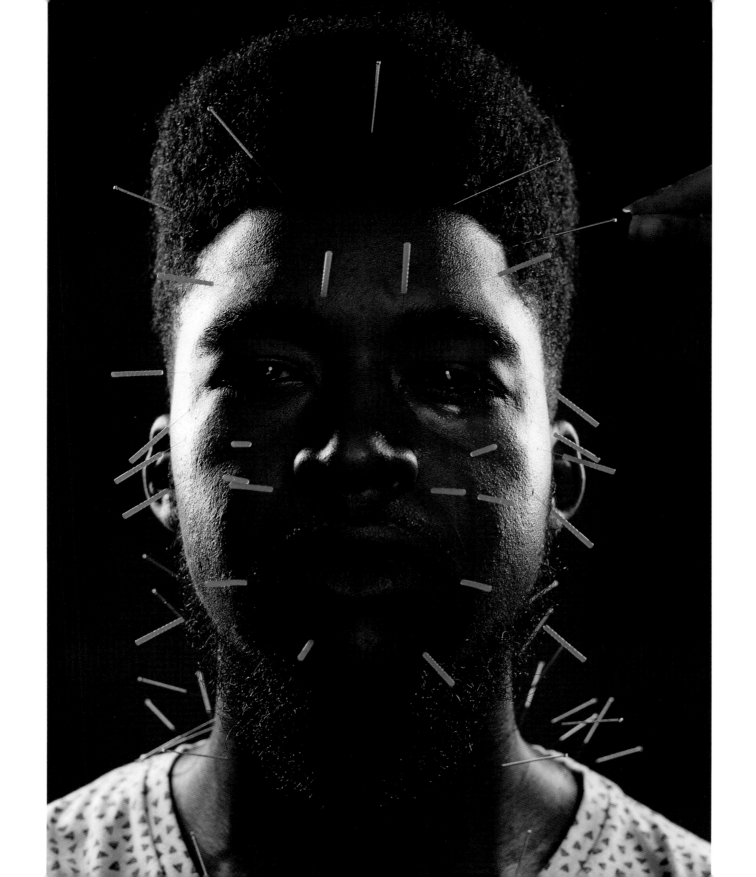

LEIGH STEIN

Civil War

I apologize for getting off on danger, but
I can't tell you any more
about my transitory fantasies involving the two of us

being consumed by prairie fire, because remember
last time? when I said I wanted to take the bones

of your hands and make them into a heart shaped brooch
for my new tweed jacket?

You totally freaked out

and I was just being romantic.

And I'm sorry that
I spent most of last night trying
to crawl inside the spine of my atlas and
I'm also sorry for eskimo kissing the hell out of
the Mason-Dixon line, but globes make
impossible pillows. Pillows make

impossible pillows. I don't know what to do any more
but ask you to sever and mail me a limb while
I work on memorizing the topography of too far away.

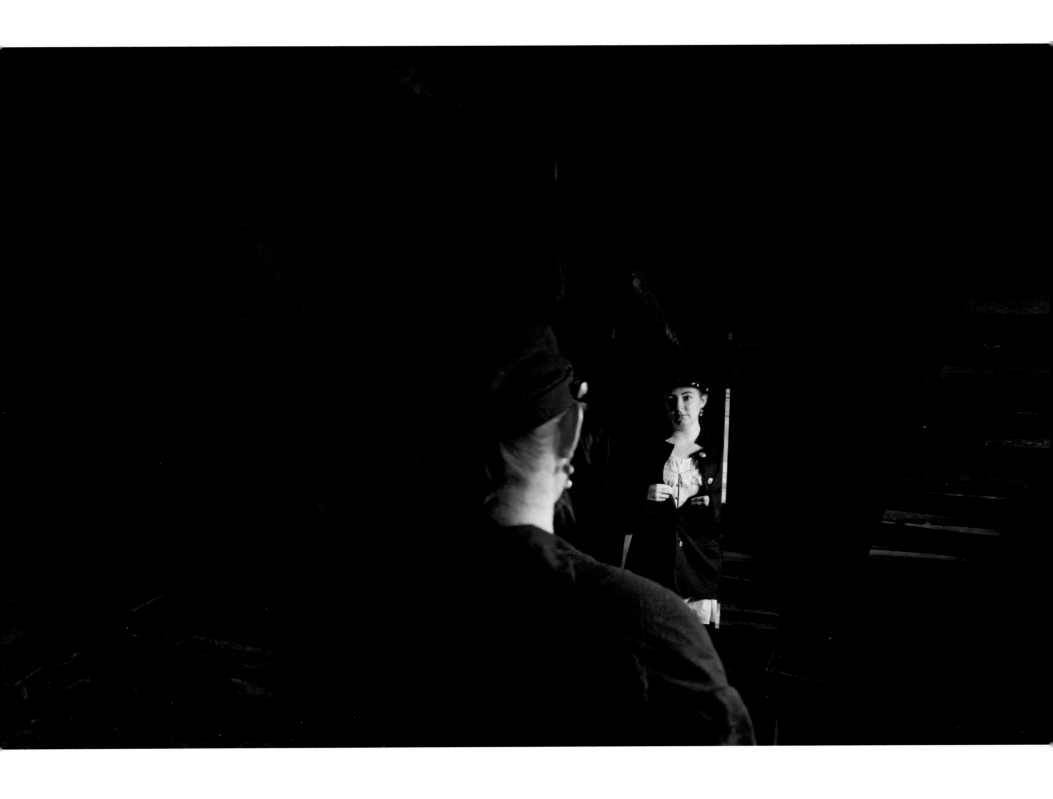

CORNELIUS EADY

from *Victims of the Latest Dance Craze*

We have all caught the itch:
The neon artist
Wiring up his legs,
The tourist couple
Recording the twist on their
Instamatic camera,
And in a factory,
A janitor asks his broom
For a waltz,
And he grasps it like a woman
He'd have to live another
Life to meet,
And he spins around the dust bin
And machines and thinks:
Is everybody happy?
And he spins out the side door,
Avoiding the cracks in the sidewalk,
Grinning as if he'd just received
The deepest kiss in the world.

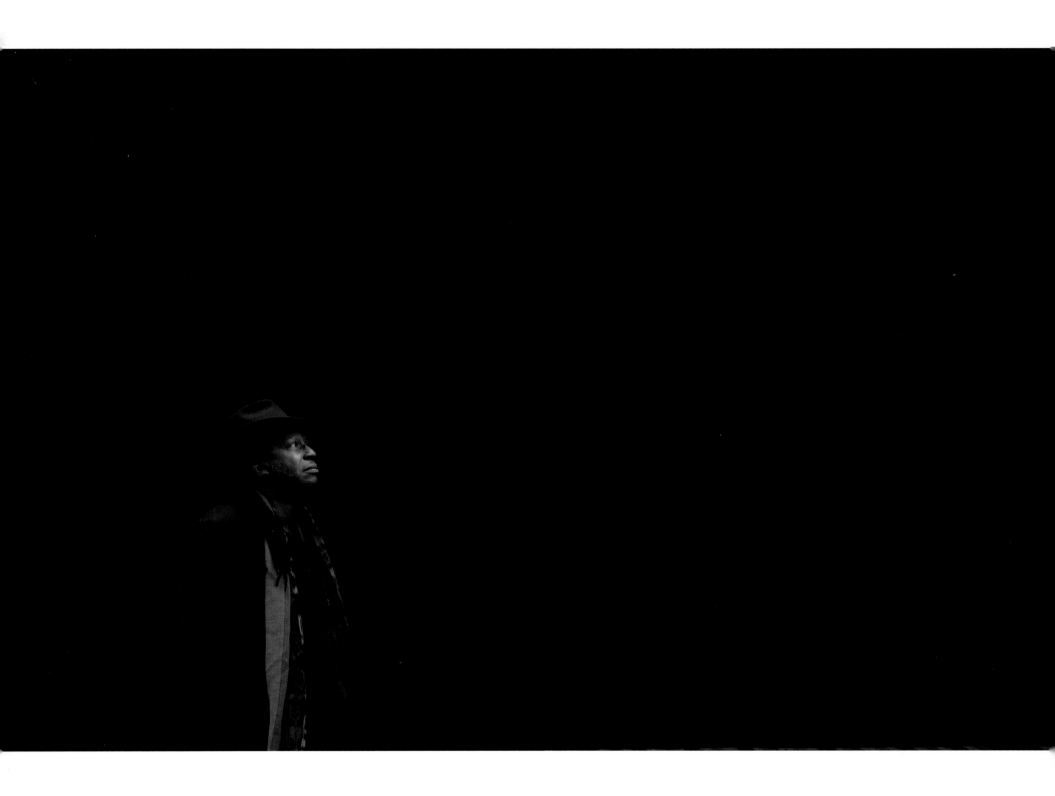

DAVID LEHMAN

January 31

The sky is crumbling into millions of paper dots
the wind blows in my face
so I duck into my favorite barber shop
and listen to Vivaldi and look in the mirror
reflecting the shopfront windows, Broadway
and 104th, and watch the dots blown by the wind
blow into the faces of the walkers outside
& here comes a thin old man swaddled in scarves,
he must be seventy-five, walking slowly,
and in his mind there is a young man dancing,
maybe seventeen years old, on a June evening—
he is that young man, I can tell, watching him walk

RHINA ESPAILLAT

Translation

Cousins from home are practicing their English,
picking out what they can, slippery vowels
queasy in their ears, stiff consonants
bristling like Saxon spears too tightly massed
for the leisurely tongues of my home town.

They frame laborious greetings to our neighbors;
try learning names, fail, try again, give up,
hug them and laugh instead, with slow blushes.
Their gestures shed echoes of morning bells,
unfold narrow streets around them like gossip.

They watch us, gleaning with expert kindness
every crumb of good will dropped in our haste
from ritual to ritual; they like the pancakes,
smile at strangers, poke country fingers
between the toes of our city roses.

Their eyes want to know if I think in this
difficult noise, how well I remember
the quiet music our grandmother spoke
in her tin-roofed kitchen, how love can work
in a language without diminutives.

What words in any language but the wind's
could name this land as I've learned it by campfire?
I want to feed them the dusty sweetness
of American roads cleaving huge spaces,
wheatfields clean and smooth as a mother's apron.

I want to tell them the goodness of people
who seldom touch, who bring covered dishes
to the bereaved in embarrassed silence,
who teach me daily that all dialogue
is hearsay, is reverie, is translation.

RAE ARMANTROUT

Exact

Quick, before you die,
describe

the exact shade
of this hotel carpet.

What is the meaning
of the irregular, yellow

spheres, some
hollow,

gathered in patches
on this bedspread?

If you love me,
worship

the objects
I have caused

to represent me
in my absence.

*

Over and over
tiers

of houses spill
pleasantly

down that hillside.
It

might be possible
to count ocurrences.

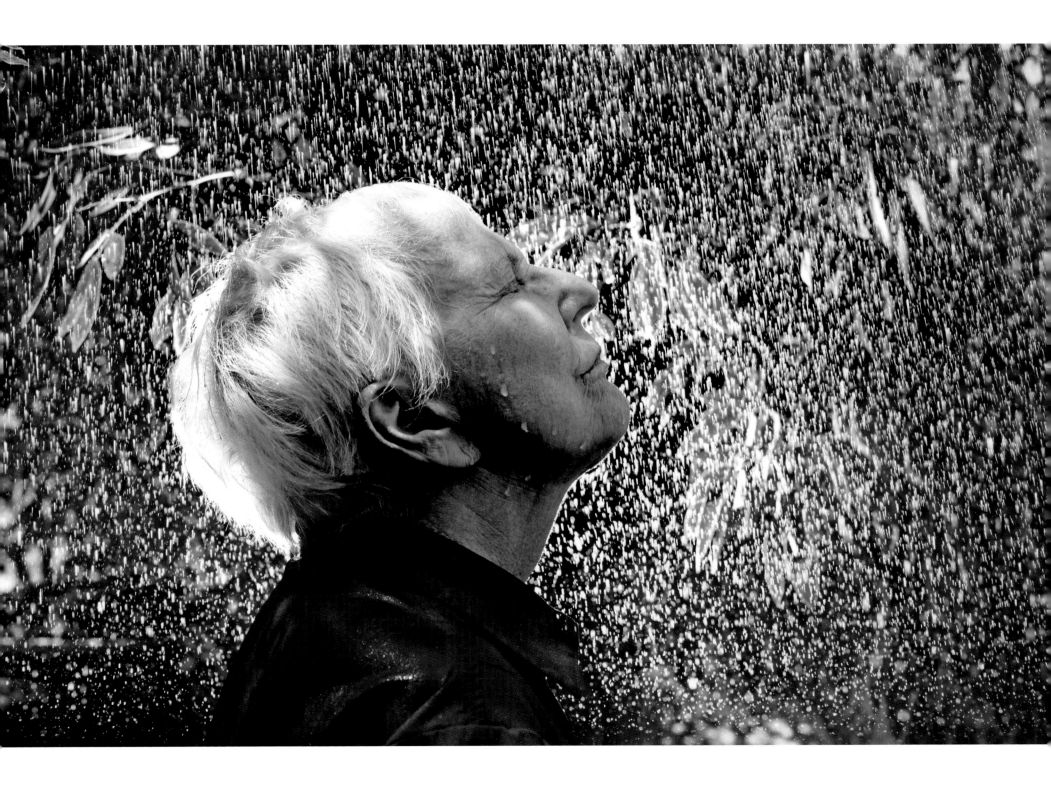

ADA LIMÓN

Service

Somewhere outside of Albuquerque, I was all
fed up with the stories about your ex-girlfriend's
Guess billboard in New York City, and to make
matters worse, I had to pee like a racehorse, or
like a girl who'd had too much to drink way
too far away from home. You stopped at a friend's
body shop to talk about a buddy who was stuck
some place in Mexico. You were talking pulling
strings and taking pulls off a brown bottle, and no
one told me where the restroom was, so I walked
back to where the hotrods were displayed like dogs
ready for a fight, baring their grills like teeth.
I was hungry, the air smelled like hot gasoline
and that sweet carnation smell of oil and coolant.
A girl pit bull came and circled me as I circled
the cars; she sniffed my ankles like I was her kin
or on some kind of rescue mission. You were still
talking, not a glance in the direction of me
and the bitch working our ways around
the souped-up Corvettes and the power tools.
The pit was glossy, well cared for, a queen
of the car shop, and when she widened
her hind legs and squatted to pee all over
one of the car's dropped canvases, I took it
as a challenge. That strong yellow stream seemed
to be saying, *Girl, no one's going to tell me*
when to take a leak, when to bow down,
when not to bite. So, right then, in the dim lights
of the strange garage, I lifted my skirt and pissed
like the hard bitch I was.

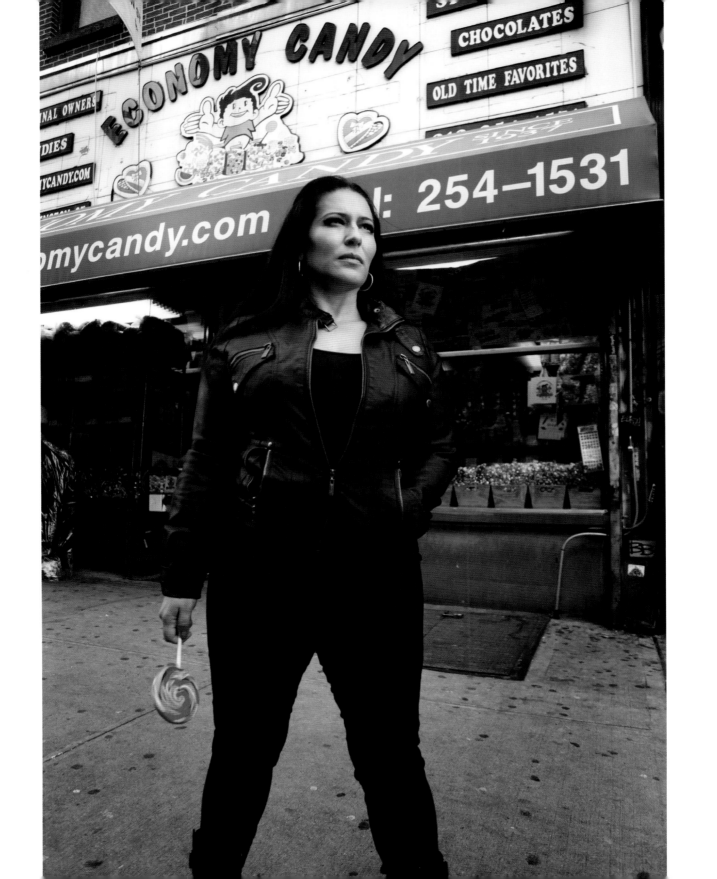

DANEZ SMITH

king the color of space/tower of molasses & marrow

I hear music rise off your skin. Each hair on your arm a tiny viola.
A wind full of bows blows & all I hear is the brown

hum of your flesh, a symphony of pigment too often drowned out
by the gun songs & sirens. Don't listen to that music.

You are the first light in the morning, the dark edge of the sun.
You are too beautiful for bullets. You, long the poster child for metal

wrecked bodies, are too precious for the dirt's greedy teeth.
You are what was left when the hot, bright stars danced

with the black endlessness around them. You are the scraps
of the beginning, you are not meant to end so soon.

I want to kiss you. Not on your mouth, but on your most
secret scars, your ashy black & journeyed knees,
your ring finger, the trigger finger, those hands
the world fears so much. I am not your enemy,

not poison, not deadly sin, not ocean hungry for blood,
nor trying to trick you. I came from the same red clay,

same ship as you. You are my brother first, my lover
second & never a God. I am sick of people always

calling us Gods. What God do you know that dies this easy?
If I believed in fire, I would think you a thing scorched

& dangerous & glowing. But I no longer believe in embers,
we know you can burn down with no flame for miles.

So thank you. Thank you for not fading to ash & memory.
Your existence is so kind.

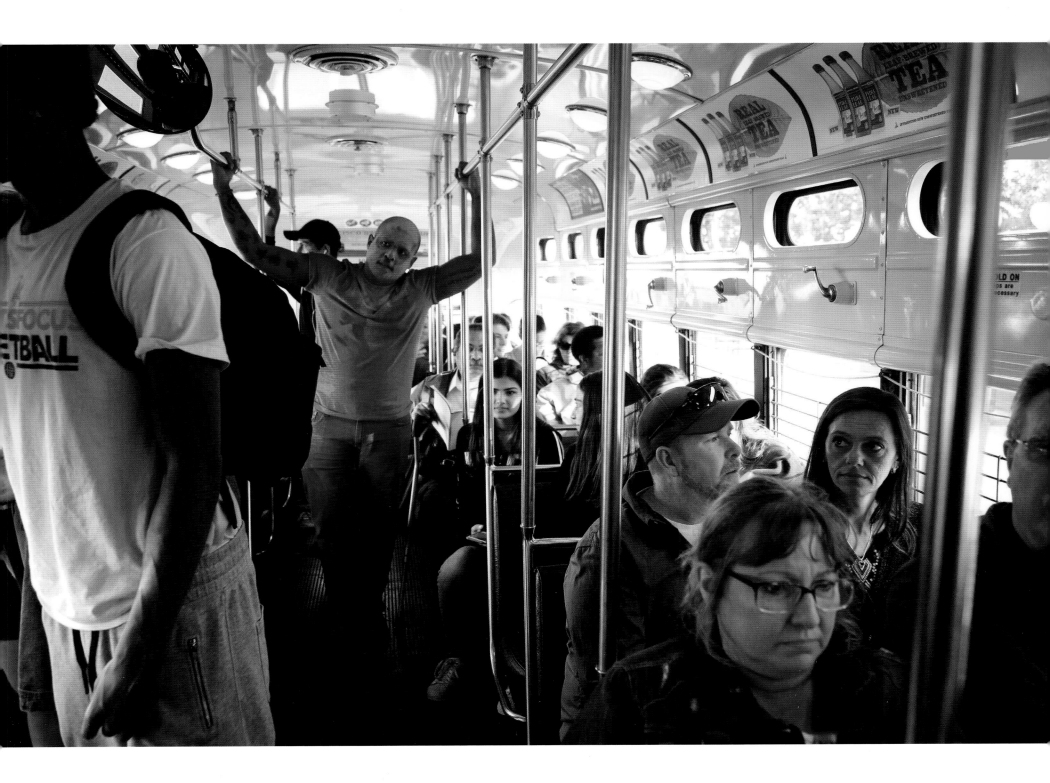

KAZIM ALI

from *Ocean Street*

in case of warmth the oceans will rise
strange cup to move through
after the continents came together

after you swam crazy through the storm to shore
after you asked for it
after you drove yourself relentlessly into the sea

we listen to one gust after the other
a gorgeous scale in the most ordinary range
drumming the time of the sea into a signature of leaves

twenty minutes of ecstasy
blue and after the blue, blue-white
a buoy, a sandpiper, a wholesale slaughter of blue

either way the harp's plucked chords
like the fog or the answer of water
dissolved into the shore's copious footnotes

transcribing the music onto ebbing surface
a missing word where continents rub together
disappear or dispel the notion
there is any such word worth knowing

a bridge collapsing along unquelled cadences of sound
when you whisper yourself to eternity
whose name did you whisper and into whose ear

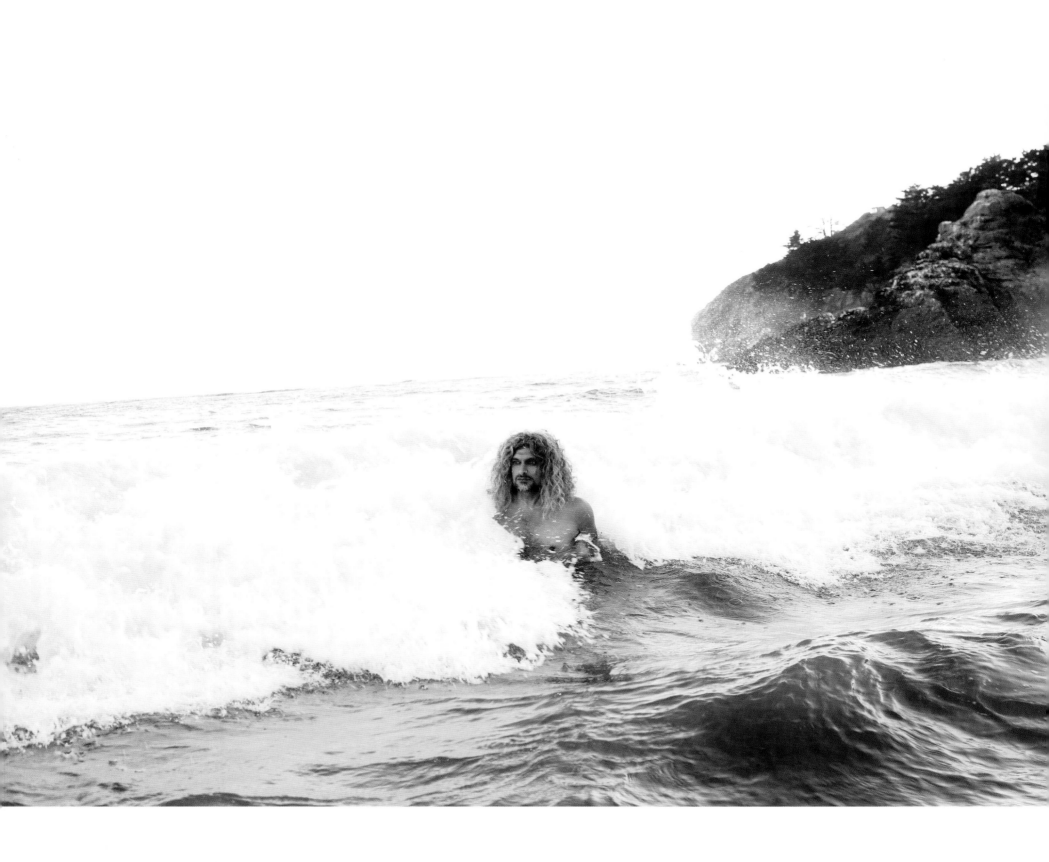

DOUGLAS KEARNEY

New Parents

pick through your blood but you won't find
what must be done with the others
the ones in ice, where you belong

choosing worries you in its mouths:
lose them to strange names and houses
board them ever in dear freezers
or let them thaw and spoil?

those you've chosen doze under wool
think of all the nights cool siblings
take them hand-in-hand and lead them
down the bleak rounds to your judgment

and when their cries rise through night's slab,
driving you, beset against their cribs,
do they grieve for those whom they have lost
or what they must have:
Your eyes burnt with love,
Your teeth keen on silence?

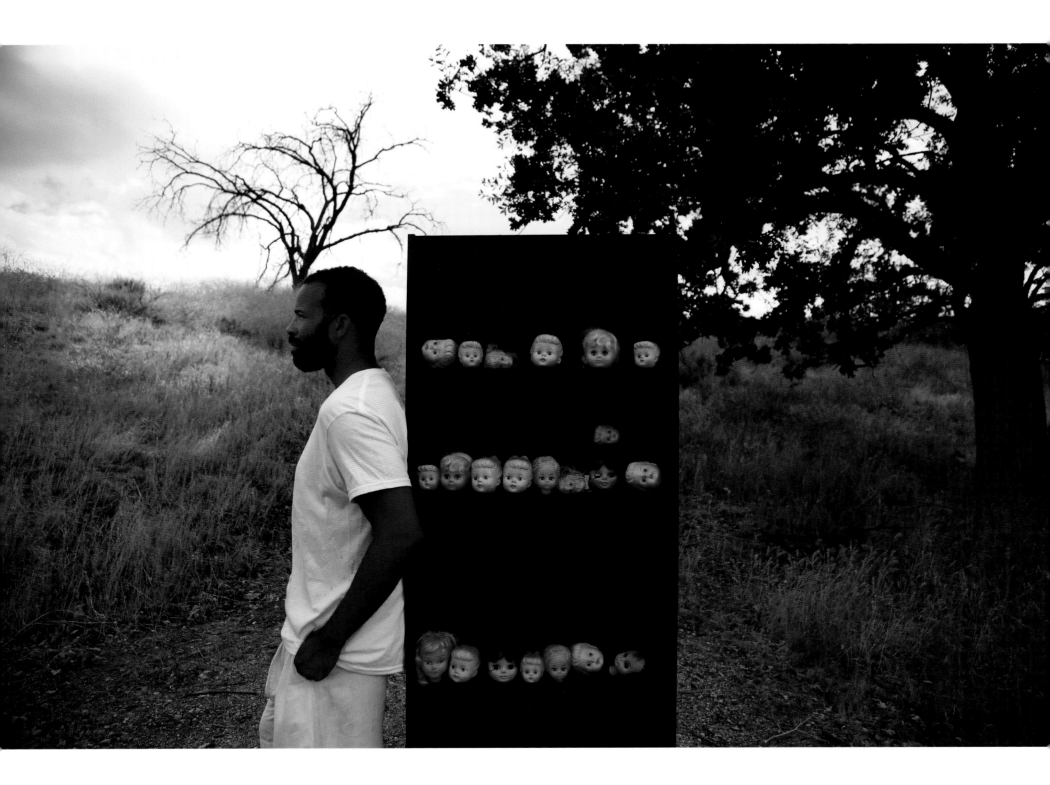

ATTICUS

We are ghosts of ourselves
until they come along.
Love fills us in,
in all our thin places.
Love gives us skin.

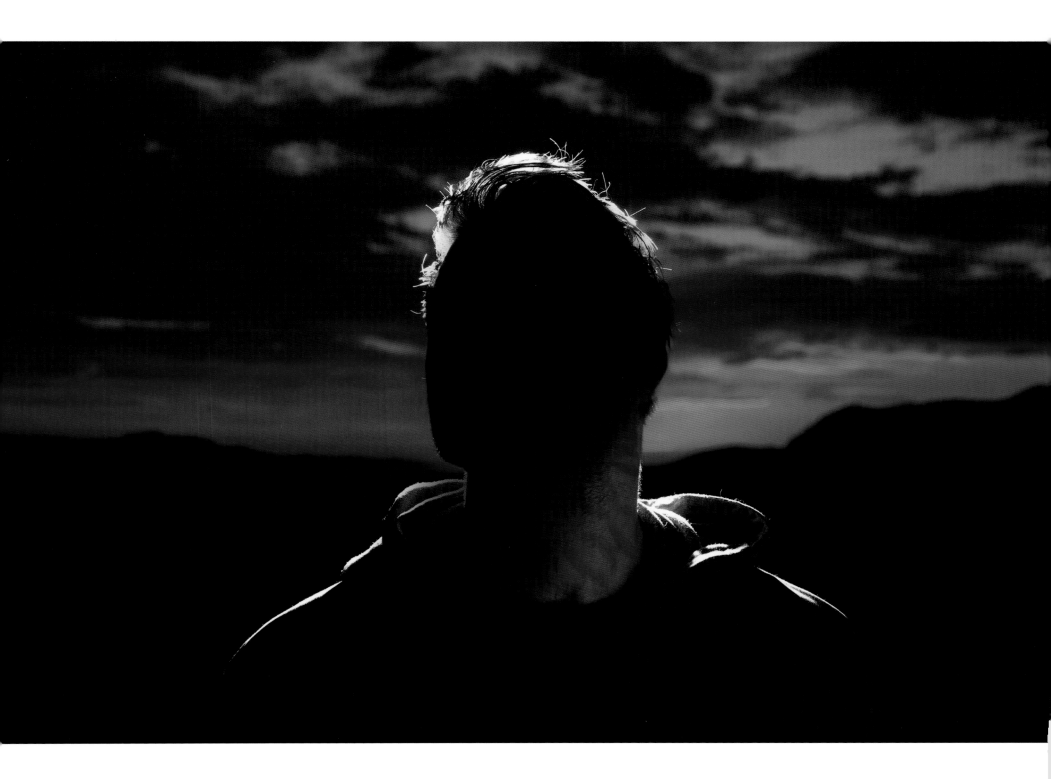

BENJAMIN ALIRE SÁENZ

To the Desert

I came to you one rainless August night.
You taught me how to live without the rain.
You are thirst and thirst is all I know.
You are sand, wind, sun, and burning sky,
The hottest blue. You blow a breeze and brand
Your breath into my mouth. You reach—then *bend*
Your force, to break, blow, burn, and make me new.
You wrap your name tight around my ribs
And keep me warm. I was born for you.
Above, below, by you, by you surrounded.
I wake to you at dawn. Never break your
Knot. Reach, rise, blow, *Sálvame, mi dios,*
Trágame, mi tierra. Salva, traga, Break me,
I am bread. I will be the water for your thirst.

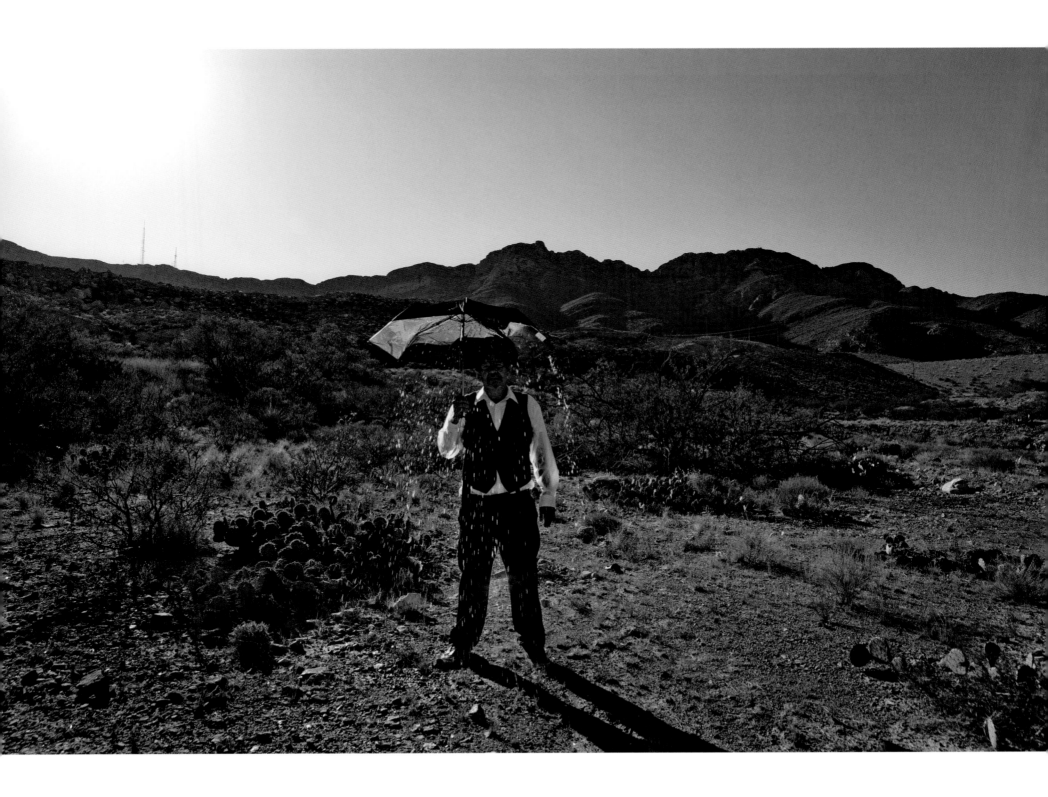

BRYNN SAITO

from *Theses on the Philosophy of History*

Roads clog with people in vehicles crossing the Golden Gate
My family is Eduardo and Mitsuo and Marilyn and Alma
and Samuel and Fumio and the twin who drank himself to death
and the auntie who drank herself to death
and the Issei and the Nisei and the Sansei with their rock faces and nightmares
Undisguise me, said the stone
Undisguise me, said the stone to the desert light
Undisguise me, said the stone to the river
Lay me down under harsh water flowing under midnight starlight
Take my face off of my face, said the stone, shake me open.

JANE HIRSHFIELD

The Woodpecker Keeps Returning

The woodpecker keeps returning
to drill the house wall.
Put a pie plate over one place, he chooses another.

There is nothing good to eat there:
he has found in the house
a resonant billboard to post his intentions,
his voluble strength as provider.

But where is the female he drums for? Where?

I ask this, who am myself the ruined siding,
the handsome red-capped bird, the missing mate.

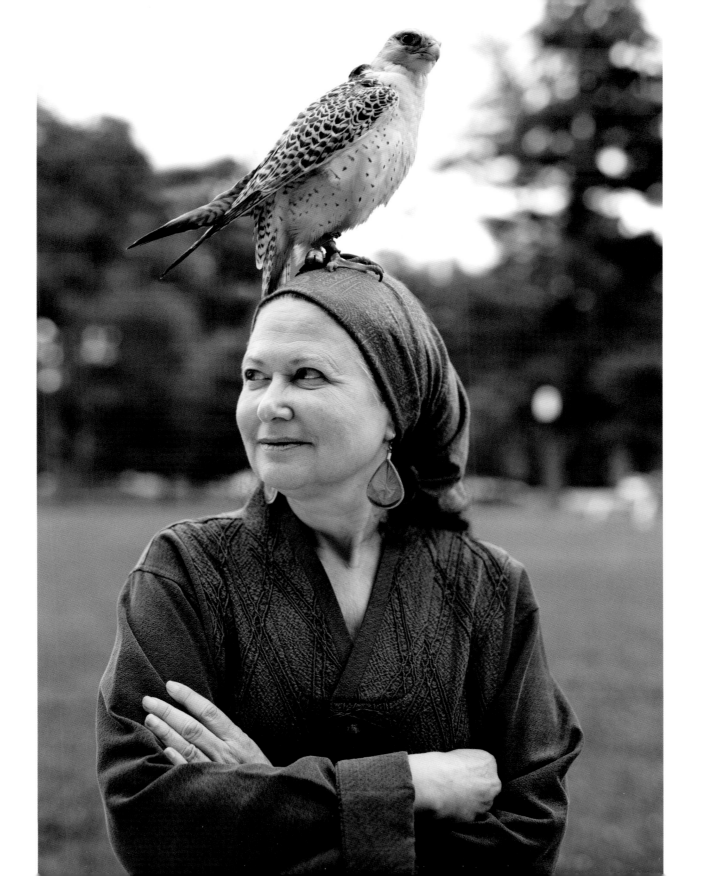

CRISTIN O'KEEFE APTOWICZ

December

When my body had forgotten its purpose,
when it just hung off my brainstem like a whipped mule.
When my hands only wrote. When my teeth only ate.
When my ass sat, my eyes read, when my reflexes
were answers to questions we all already knew.
Remember how it was then that you slid your hand
into me, a fork in the electric toaster of my body. Jesus,
where did all these sparks come from? Where was all
this heat? Remember what this mouth did last night?
And still, this morning I answer the phone like normal,
still I drink an hour's worth of strong coffee. And now
I file. And now I send an email. And remember how
my lungs filled with all that everything? Remember
how my heart was an animal you released from its cage?
Remember how we unhinged? Remember all the names
our bodies called each other? Remember how afterwards,
the steam rose from us like a pair of smiling ghosts?

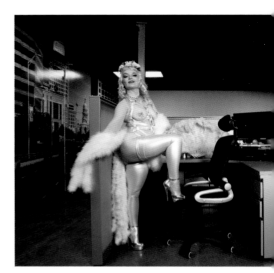

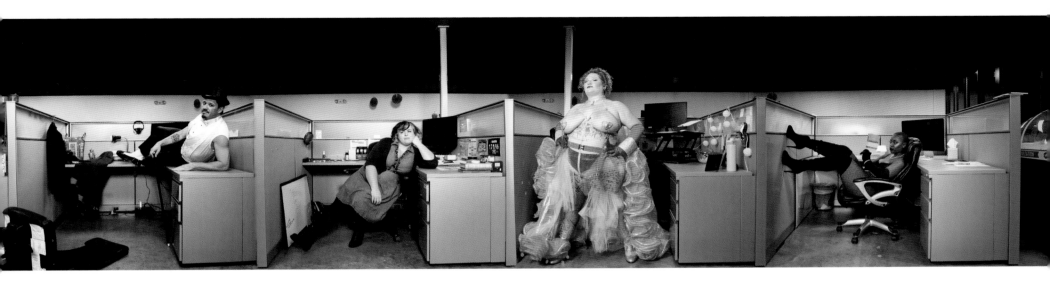

DANA LEVIN

School of Flesh

Blush for a cheek of stone.

Blush for the lips sewn tight with thread, no speech
for the dead
 maker—

You've got the razor. You can make each suture
snap.

And watch the mouth
bloom up with foam,
 as if he'd drowned himself in soap—

You lift the neck and let the head drop back.
The mouth yawns wide its prize—

White thrive.
The larval joy.
 Hot in their gorge on the stew of balms,
a moist exhale—
 as if there were a last breath, a taunt
coiling
 into your inner ear, *Good Dog*, you dig your hands in,
up-cupping
 the glossal
bed—
 saying, Graduate
of the School of Flesh, Father Conspirator—
 I will

 bite the tongue from the corpse—

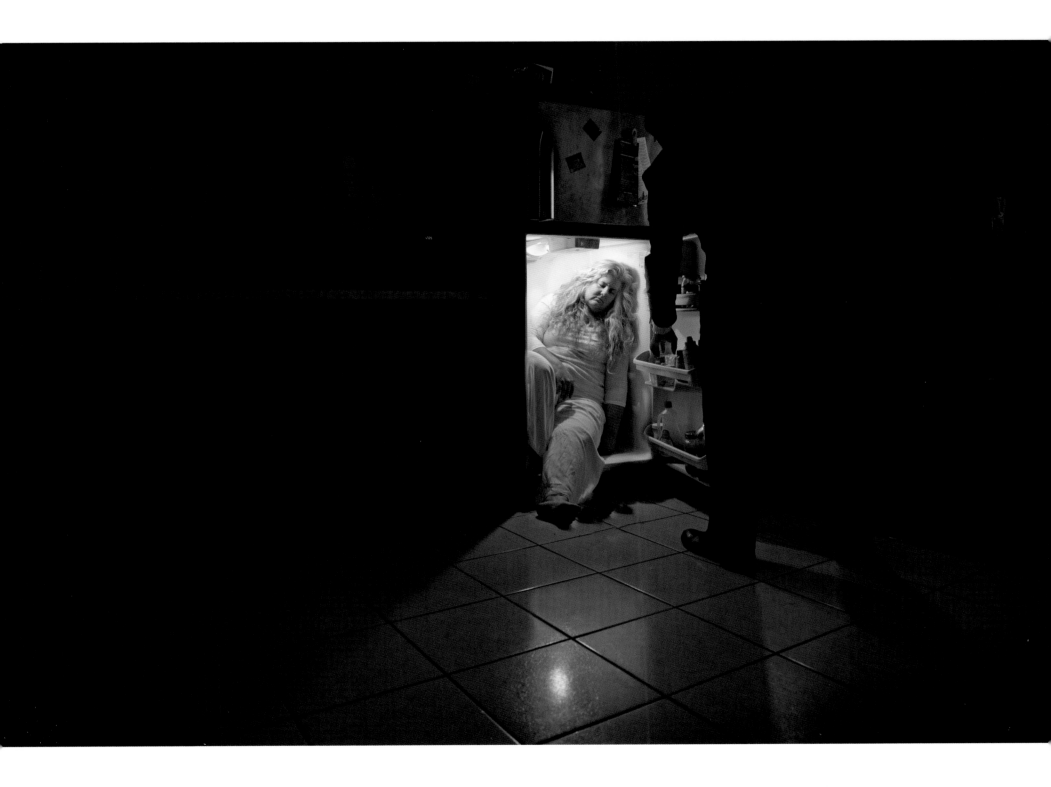

JAVIER ZAMORA

Disappeared

as in you're dragged to the darkest alleyway where dirt becomes beach for hours you can't find a place to stand without noticing the stars' sickness there's a voice where forceps flay you can't recall your hair memorizing
ditches the voice is built like invasion and says how did you raze the lines in the sand cerote your face sizzles as a wave the weight of bodies dressed in the uniform of a question blue crabs clamp your voice to night and your hands are no longer yours released all you can say is there's not enough sand where blue crabs eat sleep out of me

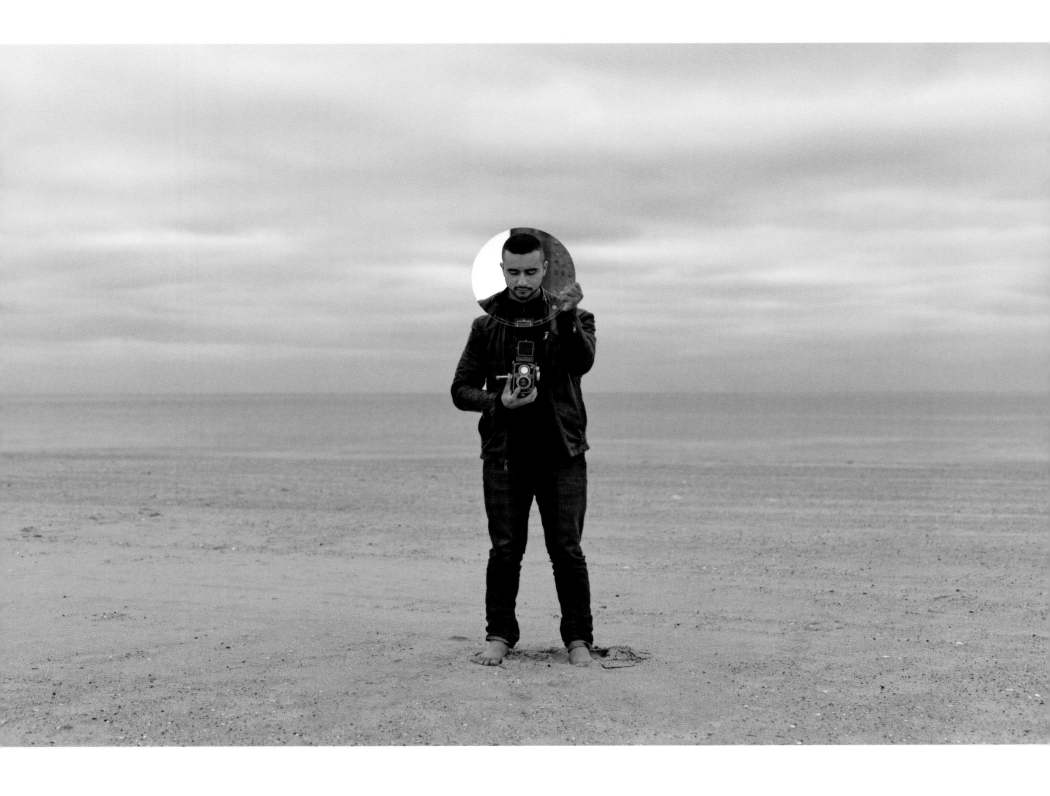

JOAN NAVIYUK KANE

Give or Take a Century

A man goes on a journey, a woman does not.
Instead, birches murmur into the song
of a bird unseen, the forest endlessly receding.

To be alone and without purpose: a seed
borne on wind to flat stones arrayed
on the remote shore. Witness to news,

songs, myelin. One of our last
a succession of ribs distinct and vast
in sudden collapse. Mother, we make

no choices. Mother, he counts our frail bones.

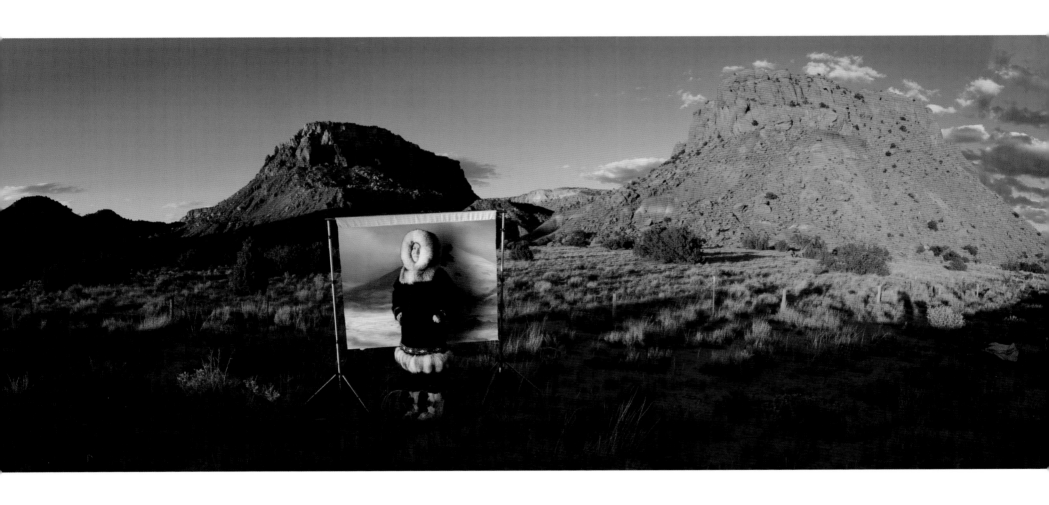

JOY HARJO

Drowning Horses

She says she is going to kill
herself. I am a thousand miles away.
Listening.
 To her voice in an ocean
of telephone sound. Grey sky
and nearly sundown; I don't ask her how.
I am already familiar with the weapons:
a restaurant that wouldn't serve her,
the thinnest laughter, another drink.
And even if I weren't closer
to the cliff edge of the talking
wire, I would still be another mirror,
another running horse.

Her escape is my own.
I tell her, yes. Yes. We ride
out for breath over the distance.
Night air approaches, the galloping
other-life.

No sound.
No sound.

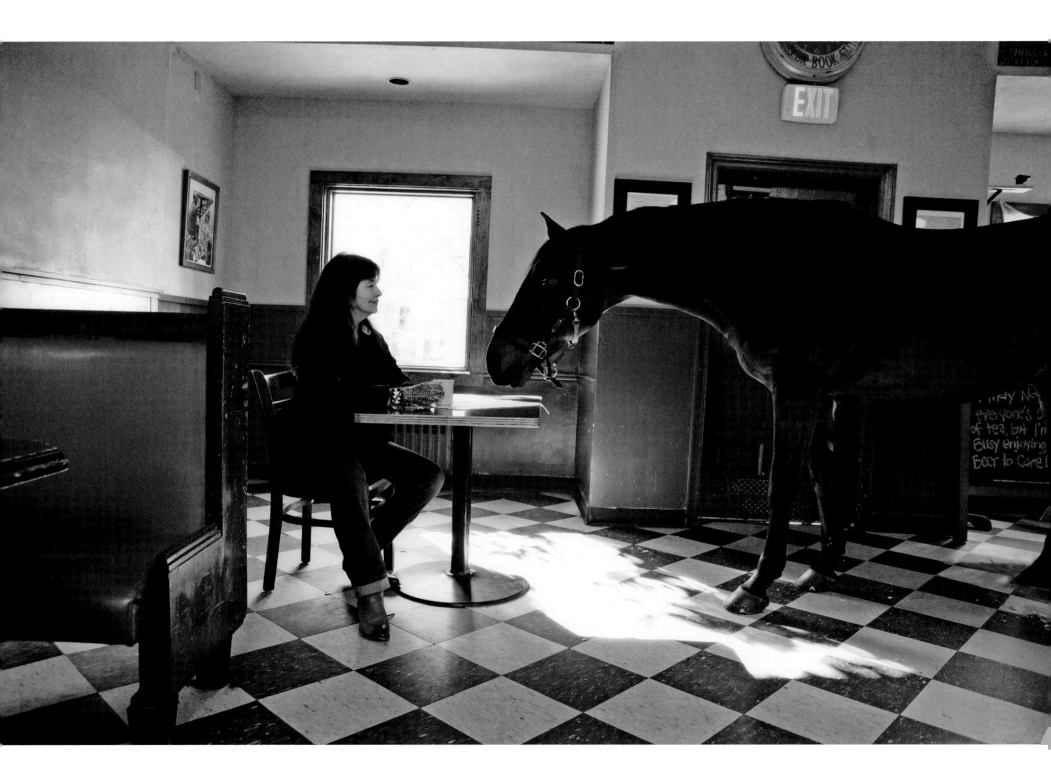

MARIE PONSOT

Among Women

What women wander?
Not many. All. A few.
Most would, now & then,
& no wonder.
Some, and I'm one,
Wander sitting still.
My small grandmother
Bought from every peddler
Less for the ribbons and lace
Than for their scent
Of sleep where you will,
Walk out when you want, choose
Your bread and your company.

She warned me, "Have nothing to lose."

She looked fragile but had
High blood, runner's ankles,
Could endure, endure.
She loved her rooted garden, her
Grand children, her once
Wild once young man.
Women wander
As best they can.

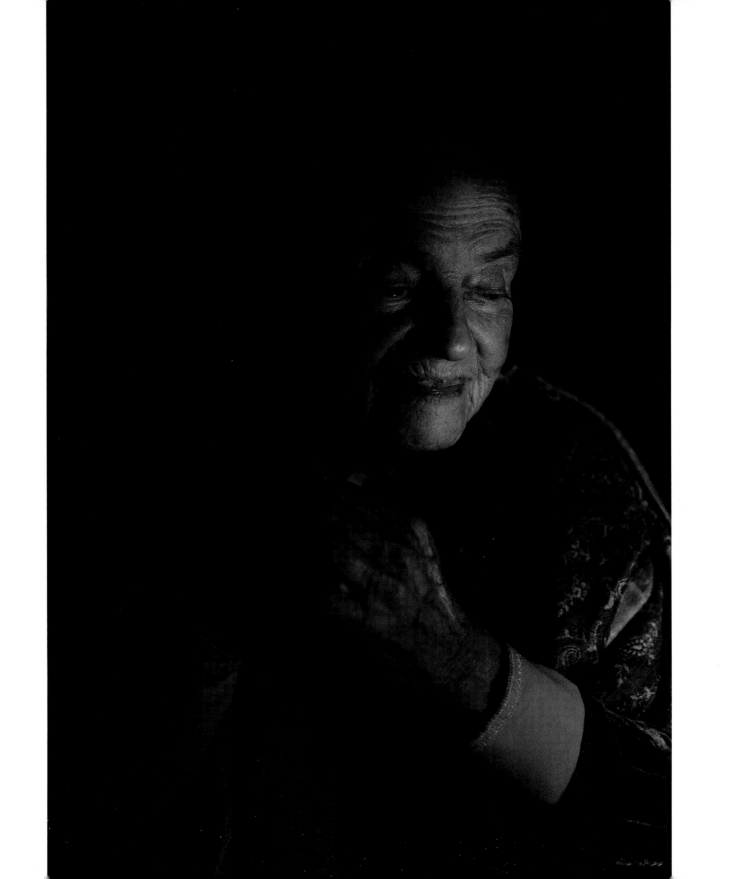

ERIKA L. SÁNCHEZ

Six Months After Contemplating Suicide

Admit it—
you wanted the end

with a serpentine
greed. How to negotiate

that strangling
mist, the fibrous

whisper?

To cease to exist
and to die

are two different things entirely.

But you knew this,
didn't you?

Some days you knelt on coins
in those yellow hours.

You lit a flame

to your shadow
and ate

scorpions with your naked fingers.

So touched by the sadness of hair
in a dirty sink.

The malevolent smell
of soap.

When instead of swallowing a fistful
of white pills,

you decided to shower,

the palm trees
nodded in agreement,

a choir
of crickets singing

behind your swollen eyes.

The masked bird
turned to you

with a shred of paper hanging
from its beak.

At dusk,
hair wet and fragrant,

you cupped a goat's face
and kissed
his trembling horns.

The ghost?

It fell prostrate,
passed through you

like a swift
and generous storm.

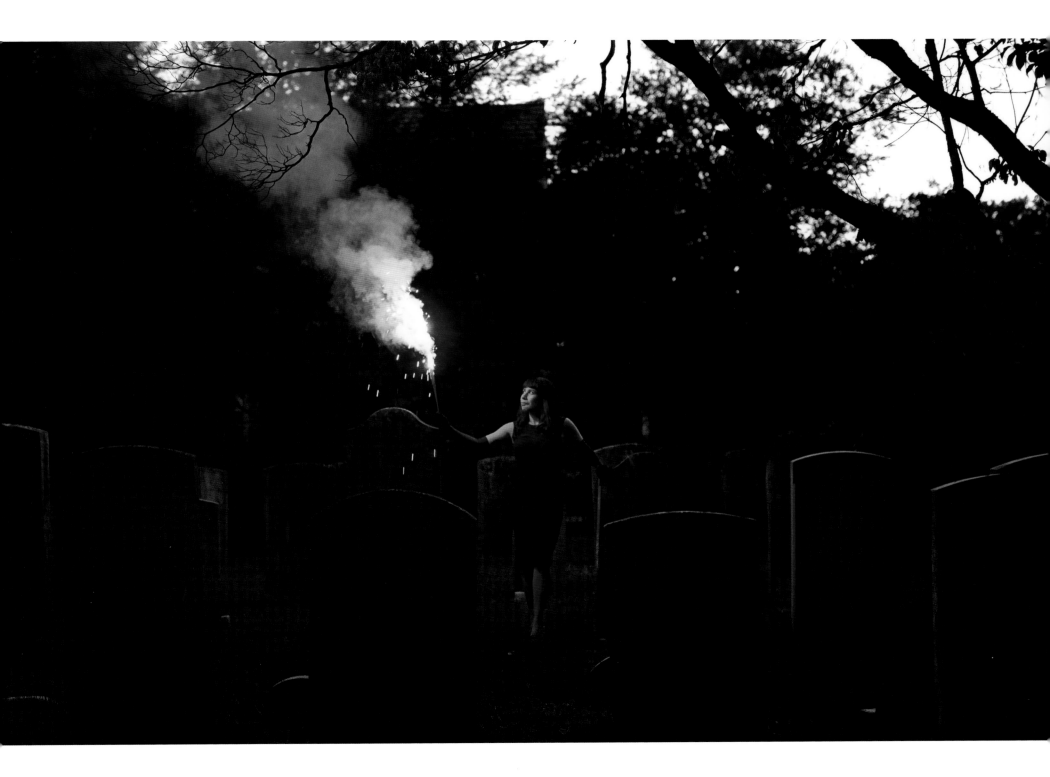

MARILYN NELSON

Daughters, 1900

Five daughters, in the slant light on the porch,
are bickering. The eldest has come home
with new truths she can hardly wait to teach.

She lectures them: the younger daughters search
the sky, elbow each other's ribs, and groan.
Five daughters, in the slant light on the porch

and blue-sprigged dresses, like a stand of birch
saplings whose leaves are going yellow-brown
with new truths. They can hardly wait to teach,

themselves, to be called "Ma'am," to march
high-heeled across the hanging bridge to town.
Five daughters. In the slant light on the porch

Pomp lowers his paper for a while, to watch
the beauties he's begotten with his Ann:
these new truths they can hardly wait to teach.

The eldest sniffs, "A lady doesn't scratch."
The third snorts back, "Knock, knock: nobody home."
The fourth concedes, "Well, maybe not in *church* . . . "
Five daughters in the slant light on the porch.

NICOLE SEALEY

The First Person Who Will Live to Be One Hundred and Fifty Years Old Has Already Been Born

Scientists say the average human
life gets three months longer every year.
By this math, death will be optional. Like a tie
or dessert or suffering. My mother asks
whether I'd want to live forever.
"I'd get bored," I tell her. "But," she says,
"there's so much to do," meaning
she believes there's much she hasn't done.
Thirty years ago she was the age I am now
but, unlike me, too industrious to think about
birds disappeared by rain. If only we had more
time or enough money to be kept on ice
until such a time science could bring us back.
Of late my mother has begun to think life
short-lived. I'm too young to convince her
otherwise. The one and only occasion
I was in the same room as the *Mona Lisa*,
it was encased in glass behind what I imagine
were velvet ropes. There's far less between
ourselves and oblivion—skin that often defeats
its very purpose. Or maybe its purpose
isn't protection at all, but rather to provide
a place, similar to a doctor's waiting room,
in which to sit until our names are called.
Hold your questions until the end.
Mother, measure my wide-open arms—
we still have *this much* time to kill.

JOSHUA MARIE WILKINSON

Lug Your Careless Body out of the Careful Dusk

Memories (a torn open roof,
taste of marmalade or warm beer,
goldfinch smacked a window
or drawn into a book with three
kinds of color & some black)

find us stopped in a doorway kissing
or whistling, pulling that door shut,
or a shirt off, a sliver out, a page
loose, a sky over,
a melon apart.

Starcrumble
bad bridges & skiffs in chop.

You still must keep
at a certain distance
for the whole body to
appear
 in the photograph.

PATRICIA SMITH

Sanctified

Every night, my mother leaned over a chipped porcelain tub.
She dragged the crotch of the day's panties over a washboard.
The crotch of those panties was cleaned thin, shredded bright.
She poured heat onto the absence of stain, pressed, rattled
the room with scrubbing, squeezed without rinsing, draped
the stiff, defeated things over the shower rod. Naked and
bubbled from the waist down, she flipped on the faucet
at the sink, ran the hot water until every surface was slimy
with steam, splashed a capful of disinfectant- meant for soiled
floors and scarred walls- into a rubber bag, filled the bag
with scalding water. She sat on the toilet, spread her legs,
stared again at the strands of silver. She twisted a tube to
the bag, snaked the tube inside her body. The slowly spreading
burn said the day was ending in God's name. She threw back
her head and bellowed. On a hook, waiting, a white dress.

PHILIP SCHULTZ

What I Like and Don't Like

I like to say hello and goodbye.
I like to hug but not shake hands.
I prefer to wave or nod. I enjoy
the company of strangers pushed
together in elevators or subways.
I like talking to cab drivers
but not receptionists. I like
not knowing what to say.
I like talking to people I know
but care nothing about. I like
inviting anyone anywhere.
I like hearing my opinions
tumble out of my mouth
like toddlers tied together
while crossing the street,
trusting they won't be squashed
by fate. I like greeting-card clichés
but not dressing up or down.
I like being appropriate
but not all the time.
I could continue with more examples
but I'd rather give too few
than too many. The thought
of no one listening anymore—
I like that least of all.

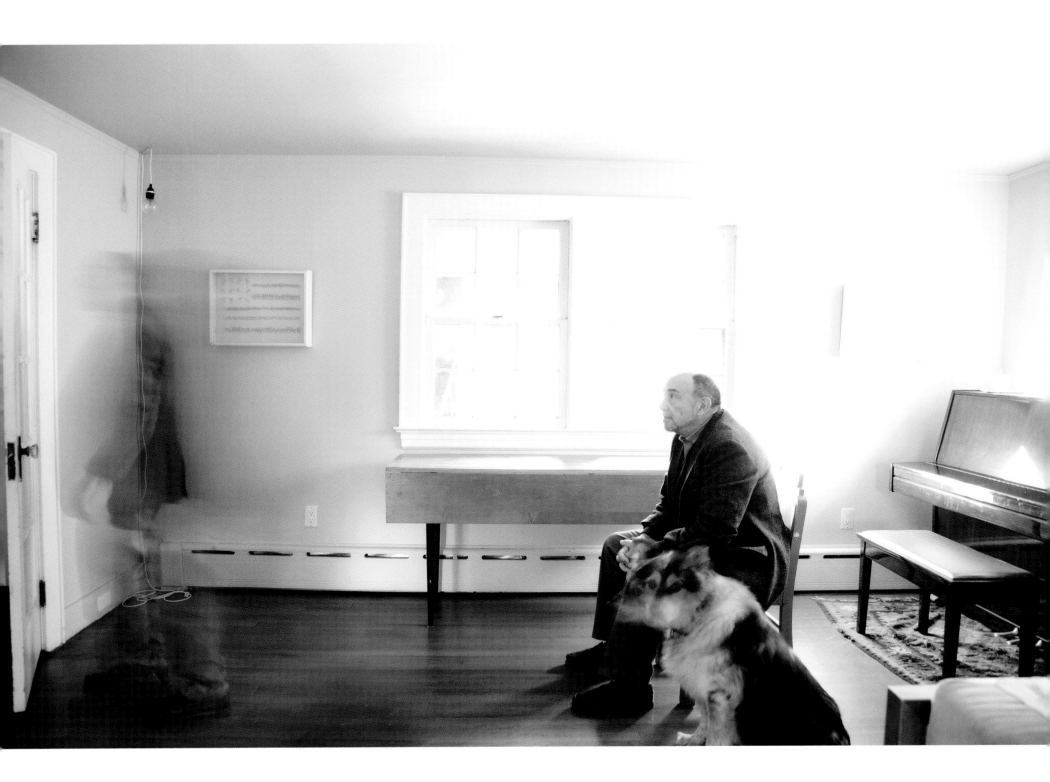

RICHARD SIKEN

Landscape With A Blur Of Conquerers

To have a thought, there must be an object—
the field is empty, sloshed with gold, a hayfield thick
with sunshine. There must be an object so land
a man there, solid on his feet, on solid ground, in
a field fully flooded, enough light to see him clearly,

the light on his skin and bouncing off his skin.
He's easy to desire since there's not much to him,
vague and smeary in his ochers, in his umbers,
burning in the open field. Forget about his insides,
his plumbing and his furnaces, put a thing in his hand

and be done with it. No one wants to know what's
in his head. It should be enough. To make something
beautiful should be enough. It isn't. It should be.
The smear of his head—I paint it out, I paint it in
again. I ask it what it wants. I want to be a *cornerstone*,

says the head. *Let's kill something*. Land a man in a
landscape and he'll try to conquer it. Make him
handsome and you're a fascist, make him ugly and
you're saying nothing new. The conqueror suits up
and takes the field, his horse already painted in

beneath him. What do you do with a man like that?
While you are deciding, more men ride in. The hand
sings *weapon*. The mind says *tool*. The body swerves
in the service of the mind, which is evidence of
the mind but not actual proof. More conquerors.

They swarm the field and their painted flags unfurl.
Crown yourself with leaves and stake your claim
before something smears up the paint. I turned away
from darkness to see daylight, to see what would
happen. What happened? What does a man want?

Power. The men spread, the thought extends. I paint
them out, I paint them in again. A blur of forces.
Why take more than we need? Because we can.
Deep footprint, it leaves a hole. You'd break your
heart to make it bigger, so why not crack your skull

when the mind swells. A thought bigger than your
own head. Try it. Seriously. Cover more ground.
I thought of myself as a city and I licked my lips.
I thought of myself as a nation and I wrung my hands,
I put a thing in your hand. Will you defend yourself?

From me, I mean. Let's kill something. The mind
moves forward, the paint layers up: glop glop and
shellac. I shovel the color into our faces, I shovel our
faces into our faces. They look like me. I move them
around. I prefer to blame others, it's easier. King me .

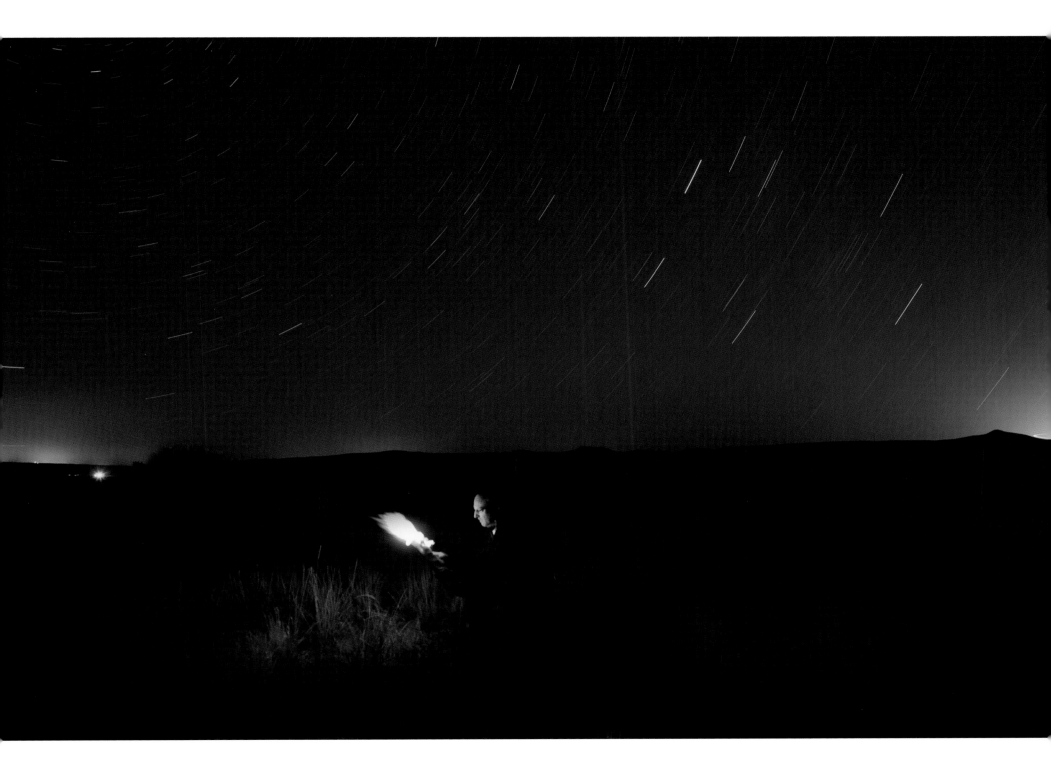

TED KOOSER

Abandoned Farmhouse

He was a big man, says the size of his shoes
on a pile of broken dishes by the house;
a tall man too, says the length of the bed
in an upstairs room; and a good, God-fearing man,
says the Bible with a broken back
on the floor below the window, dusty with sun;
but not a man for farming, say the fields
cluttered with boulders and the leaky barn.

A woman lived with him, says the bedroom wall
papered with lilacs and the kitchen shelves
covered with oilcloth, and they had a child,
says the sandbox made from a tractor tire.
Money was scarce, say the jars of plum preserves
and canned tomatoes sealed in the cellar hole.
And the winters cold, say the rags in the window frames.
It was lonely here, says the narrow country road.

Something went wrong, says the empty house
in the weed-choked yard. Stones in the fields
say he was not a farmer; the still-sealed jars
in the cellar say she left in a nervous haste.
And the child? Its toys are strewn in the yard
like branches after a storm—a rubber cow,
a rusty tractor with a broken plow,
a doll in overalls. Something went wrong, they say.

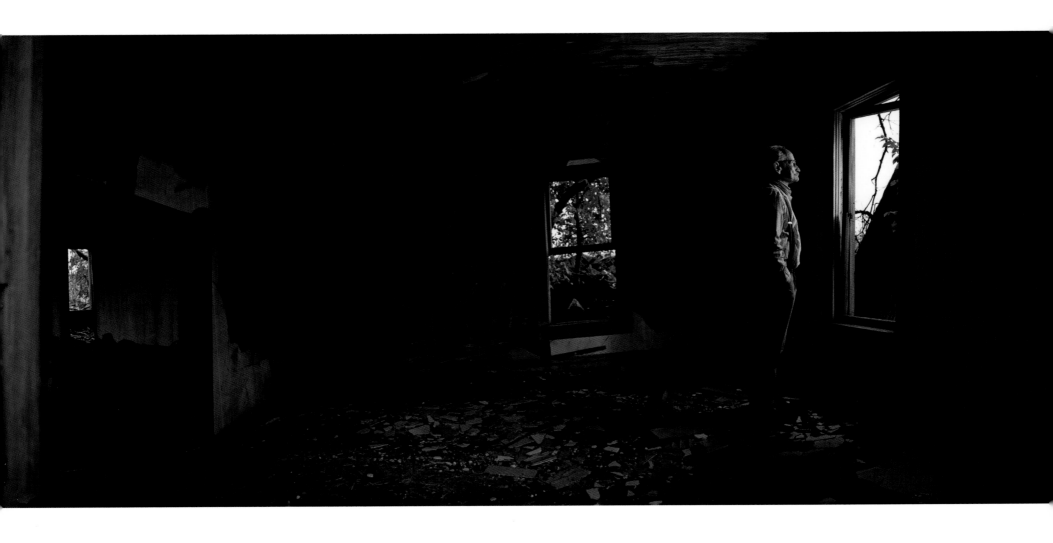

TERRANCE HAYES

from Music To Interrogate By

I will have to admit I was one of them. I believed the holes
would be erased. Our leader knew this floating up a mountain
on the backs of soldiers. I wanted only to be free, a cup of water,
if not rain. But the war spread to the edges of the state, narrow
closets opened in the field, the petals were white as cuffs.
What I had was the same as power, a dampness in the thread
of an old jacket. There was something sad and unforgiving
about our leader's accent, his short yellow tongue like a pencil
with no eraser. When they ask or wonder without asking
what I did when I saw the slick and shameful, the naked men
hanging an inch from the ground, when they ask what I did
when I heard of the prisoners, when I heard of the wars against
ideas, when they exiled strangers, what will I say? That's why
God et cetera? Who said you need not arm your children,
nor send them off to war? Who cares about the past worn
smooth by error and friction? The water of damage lay charged
in my mouth, bleeding its oil. I walked the back roads
of my property with one shoe untied and the other in my hand.

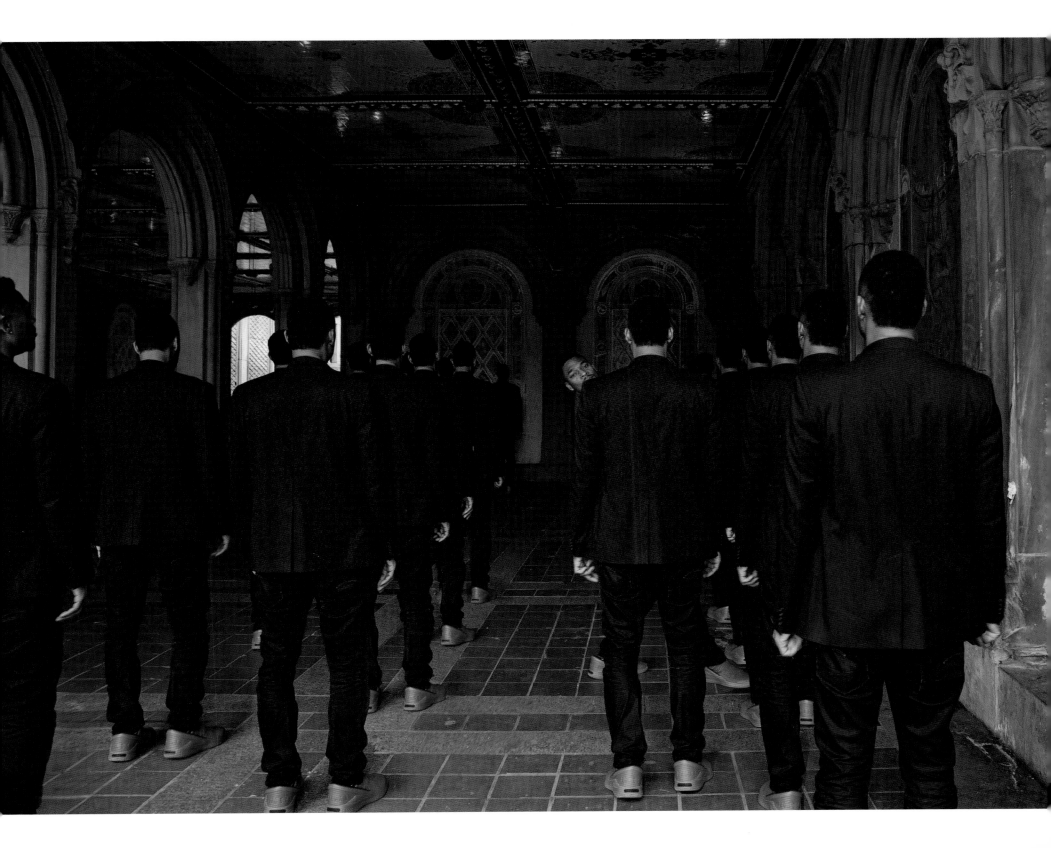

TONY HOAGLAND

Bible Study

Who would have imagined that I would have to go
a million miles away from the place where I was born
to find people who would love me?
And that I would go that distance and that I would find those people?

In the dream JoAnne was showing me how much arm to amputate
if your hand gets trapped in the gears of the machine;
if you acted fast, she said, you could save everything above the wrist.
You want to keep a really sharp blade close by, she said.

Now I raise that hand to scratch one of those nasty little
scabs on the back of my head, and we sit outside and watch
the sun go down, inflamed as an appendicitis
over western Illinois — which then subsides and cools into a smooth gray sea.

Who knows, this might be the last good night of summer.
My broken nose is forming an idea of what's for supper.
Hard to believe that death is just around the corner.
What kind of idiot would think he even had a destiny?

I was on the road for so long by myself,
I took to reading motel Bibles just for company.
Lying on the chintz bedspread before going to sleep,
still feeling the motion of the car inside my body,
I thought some wrongness in my self had made me that alone.

And God said, *You are worth more to me*
than one hundred sparrows.
And when I read that, I wept.
And God said, *Whom have I blessed more than I have blessed you?*

And I looked at the mini bar
and the bad abstract hotel art on the wall
and the dark TV set watching like a deacon.
And God said, *Survive. And carry my perfume among the perishing.*

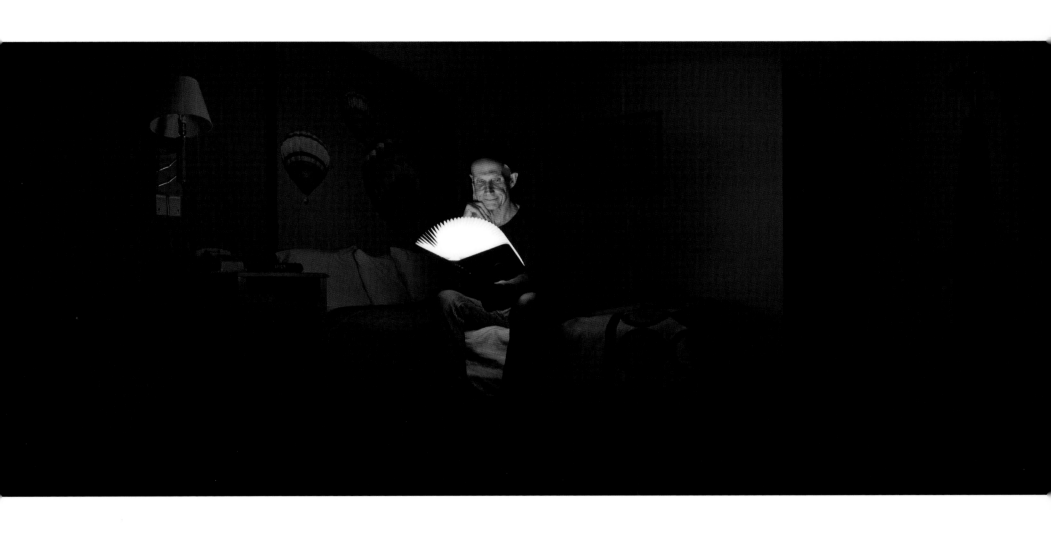

LEILA CHATTI

Portrait Of The Illness As Nightmare

No matter how many times you ring the bell in the bad dark,
no one will let you in. You face the fun

house with its mirrors on the outside
so everyone can see. And everyone looks. You are in your underwear

and the room is cold. The doctor's stethoscope pressed to you
becomes suddenly a snake. Your heart hisses in its cage. Your heart sputters,

a doused flame. You are drowning in your blue paper gown, which recedes
in the back like an ocean, your skin a bank of hot sand.

The horizon bleeds and the days and you
wander lost in a city of scalpels where everything glitters

and pills fade like moons on your tongue. You sidle through
sterile labyrinths and piss in a cup. You wait in a room like a chapel

or the belly of a beast. Either way, you think
something will save you, you believe this the whole fearsome time.

Your god comes and he is ordinary and terrible. He confers
with the doctors at your kitchen table and tells you to eat

your clots, round as peas. You want dessert. You want to
deceive him, but he, like you, has eyes, and uses them.

You are grounded, in the ground. The pit is a tub
and you are washing in your body's black water. You rise

like a fever. You writhe on a bed on a stage, the strings reaching
toward heaven. There is a momentary break for everyone

else: intermission. They chatter in the lobby. You babble
symptoms in a white confessional. You fall from a great height and land

on a gurney. You are at the front of a classroom and you are stripped
to your bones. The doctor points to your pelvis. You model

the tumors—in this light they look pretty, like jewels.

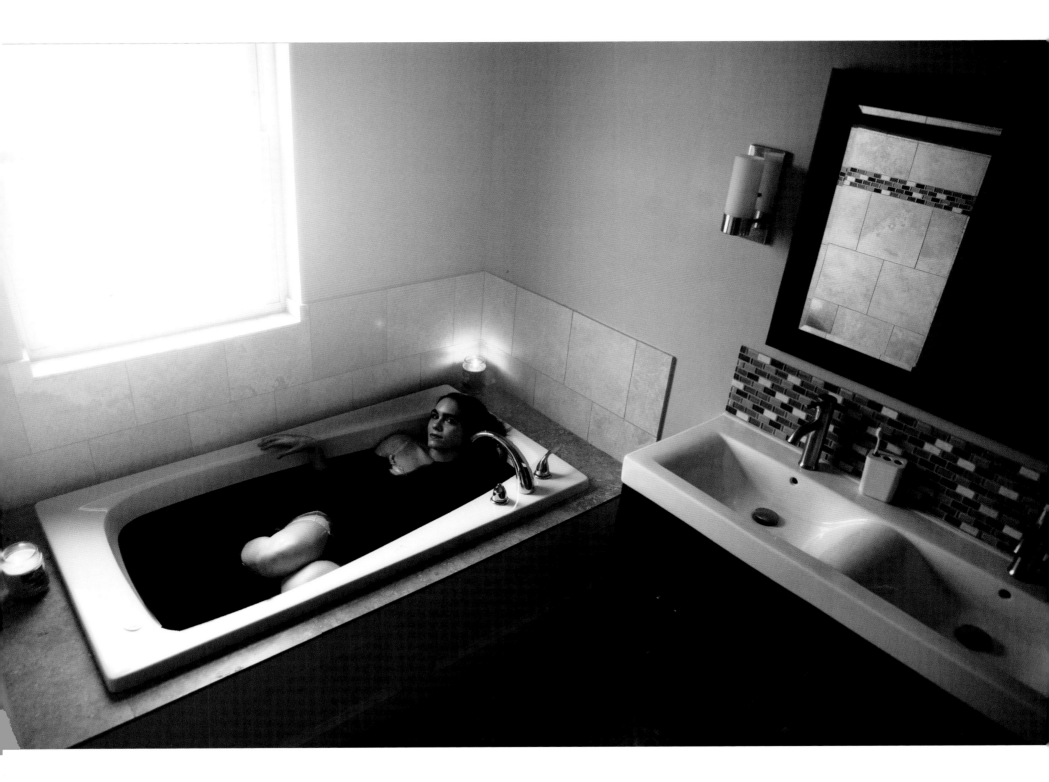

CLEMENTINE VON RADICS

Pity the Woman Who Will Love You When I Am Done

She will show up to your first date
with a dustpan and broom,
ready to pick up all the pieces
I left you in.
She will hear my name so often
it will begin to dig holes in her. That
is where doubt will grow.
She will lookat your neck, your thin
hips, your mouth,wondering
at the way I touched you.
Offer you her lips, her throat,
the soft pillow of her thighs,
a sacrifice to the altar of virtue.
She will make you
all the promises I didand some
I never could.
She will hear only
the terrible stories.
How I drank. How I lied.
She will wonder *(as I have)*
how someoneas wonderful as you
could love a sinkhole like the woman
who came before her. Still,
she will compete

with my ghost.
She will understand why
you do not lookin the back of closets.
Why you are afraid of every groan
in the cold sweat of night.
She will know
every corner of you
is haunted by me.

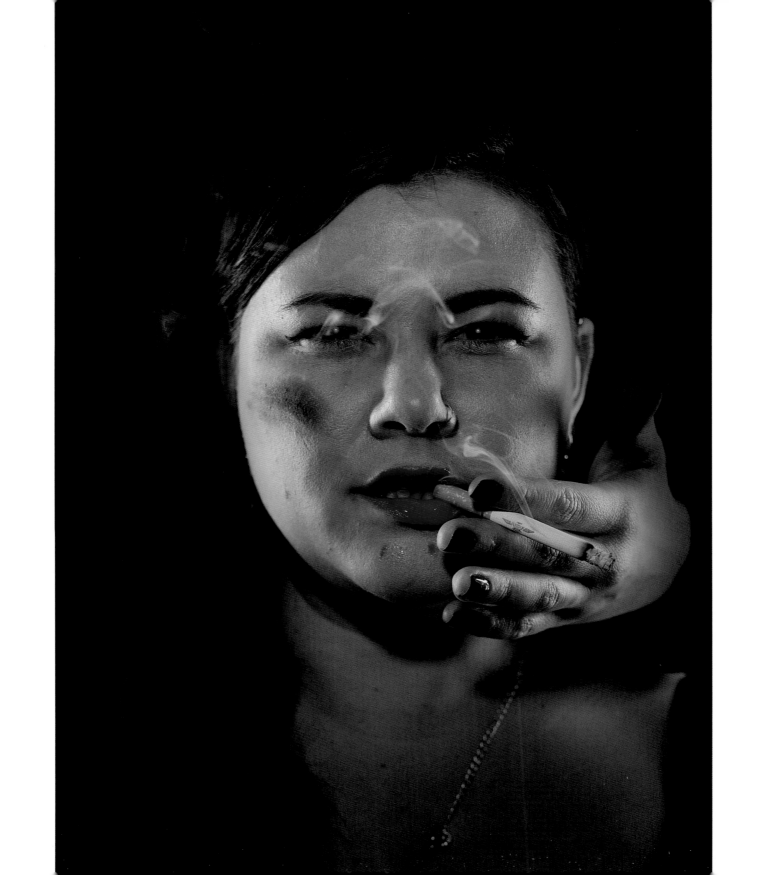

DOUG ANDERSON

Night Ambush

We are still, lips swollen with mosquito bites.
A tree line opens out onto paddies
quartered by dikes, a moon in each,
and in the center, the hedged island of a village
floats in its own time, ribboned with smoke.
Someone is cooking fish.
Whispers move across water.
Children and old people. Anyone between
is a target. It is so quiet
you can hear a safety clicked off
all the way on the other side.
Things live in my hair. I do not bathe.
I have thrown away my underwear.
I have forgotten the why of everything.
I sense an indifference larger than anything
I know. All that will remain of us
is rusting metal disappearing in vines.
Above the fog that clots the hill ahead
a red tracer arcs and dims.
A black snake slides off the paddy dike
into the water and makes the moon shiver.

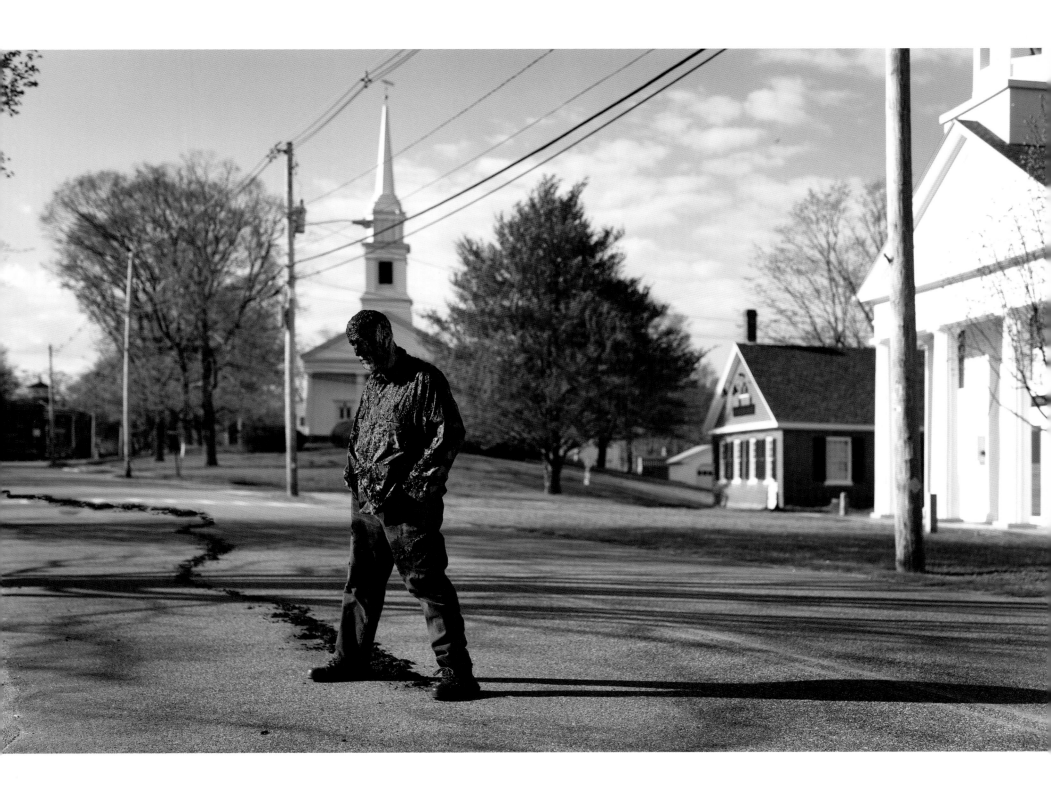

EDUARDO C. CORRAL

In Colorado My Father Scoured and Stacked Dishes

in a Tex-Mex restaurant. His co-workers,
unable to utter his name, renamed him Jalapeño.

If I ask for a goldfish, he spits a glob of phlegm
into a jar of water. The silver letters

on his black belt spell *Sangrón*. Once, borracho,
at dinner, he said: Jesus wasn't a snowman.

Arriba Durango. Arriba Orizaba. Packed
into a car trunk, he was smuggled into the States.

Frijolero. Greaser. In Tucson he branded
cattle. He slept in a stable. The horse blankets

oddly fragrant: wood smoke, lilac. He's an illegal.
I'm an Illegal-American. Once, in a grove

of saguaro, at dusk, I slept next to him. I woke
with his thumb in my mouth. ¿No qué no

tronabas, pistolita? He learned English
by listening to the radio. The first four words

he memorized: In God We Trust. The fifth:
Percolate. Again and again I borrow his clothes.

He calls me Scarecrow. In Oregon he picked apples.
Braeburn. Jonagold. Cameo. Nightly,

to entertain his cuates, around a campfire,
he strummed a guitarra, sang corridos. Arriba

Durango. Arriba Orizaba. Packed into
a car trunk, he was smuggled into the States.

Greaser. Beaner. Once, borracho, at breakfast,
he said: The heart can only be broken

once, like a window. ¡No mames! His favorite
belt buckle: an águila perched on a nopal.

If he laughs out loud, his hands tremble.
Bugs Bunny wants to deport him. César Chávez

wants to deport him. When I walk through
the desert, I wear his shirt. The gaze of the moon

stitches the buttons of his shirt to my skin.
The snake hisses. The snake is torn.

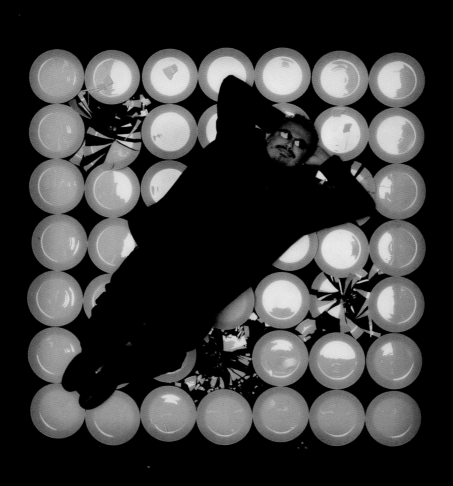

GABRIELLE CALVOCORESSI

Shave

Like the buck I am I turn my head
side to side. I hear the leaves
rustle. I shake my head a little
and birds reel 'round the forest.
I am no branch. My head turns
to the side. I see out my side
eye. The deep pool of the eye
sees itself pool in the mirror.
I oil myself 'til I am all a lather.
My chest heaves out
so my full heart can abandon
the ribs' stockade. Where
the bullet would go if the hunter
were a good shot: that's
where I place the razor.
I make my skin taut. I pull
my own neck back and to
the side. I come for myself.

Yes, I was a lady once but now
I take the blade and move it
slowly past the jugular, up
the ridge of my chin where
the short hairs glisten. I was
once ashamed. It was a thing
I did in private. My own self
my quarry. No more.
Look how the doe comes 'round
and also the doves and also
the wolf who lets me pass.
The fox offers me the squirrel's
hide to buff myself to shining.
There is no such thing except
the smoothness of my face.

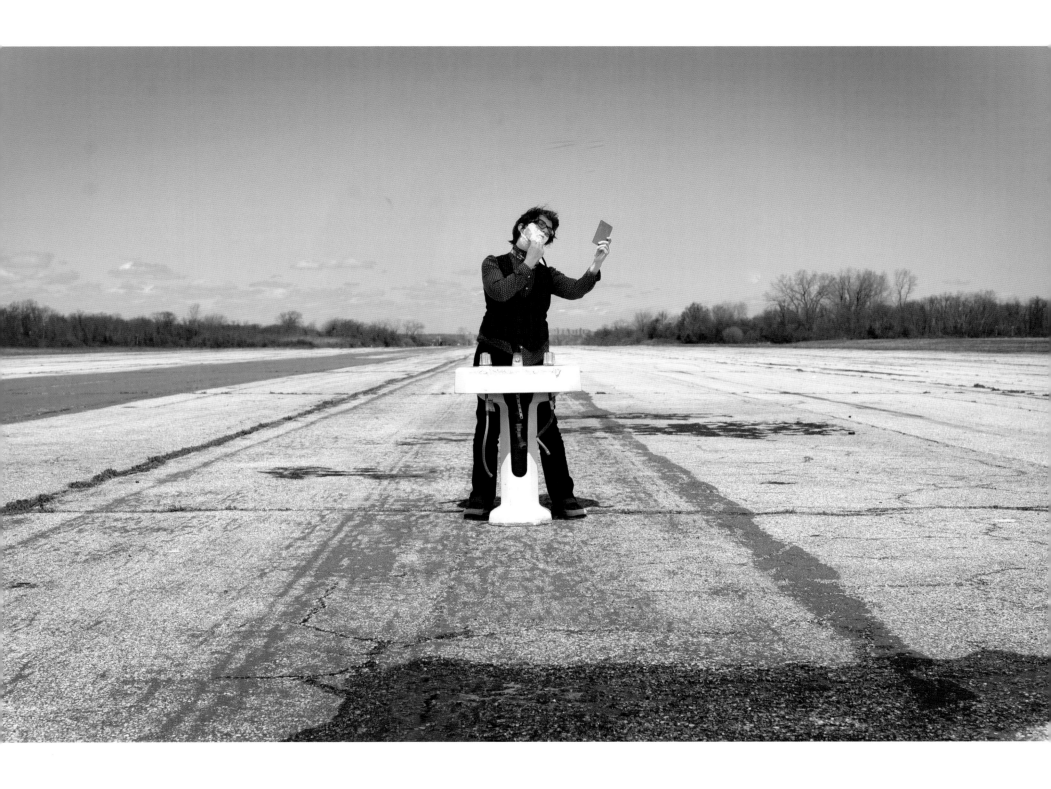

ARTHUR SZE

The Negative

A man hauling coal in the street is stilled forever.
Inside a temple, instead of light

a slow shutter lets the darkness in.
I see a rat turn a corner running from a man with a chair trying to smash it,

see people sleeping at midnight in a Wuhan street on bamboo beds,
a dead pig floating, bloated, on water.

I see a photograph of a son smiling who two years ago fell off a cliff
and his photograph is in each room of the apartment.

I meet a woman who had smallpox as a child, was abandoned by her mother
but who lived, now has two daughters, a son, a son-in-law;

they live in three rooms and watch a color television.
I see a man in blue work clothes whose father was a peasant

who joined the Communist party early but by the time of the Cultural
 Revolution
had risen in rank and become a target of the Red Guards.

I see a woman who tried to kill herself with an acupuncture needle
but instead hit a vital point and cured her chronic asthma.

A Chinese poet argues that the fundamental difference between
 East and West
is that in the East an individual does not believe himself

in control of his fate but yields to it.
As a negative reverses light and dark

these words are prose accounts of personal tragedy becoming metaphor,
an emulsion of silver salts sensitive to light,

laughter in the underground bomb shelter converted into a movie theater,
lovers in the Summer Palace park.

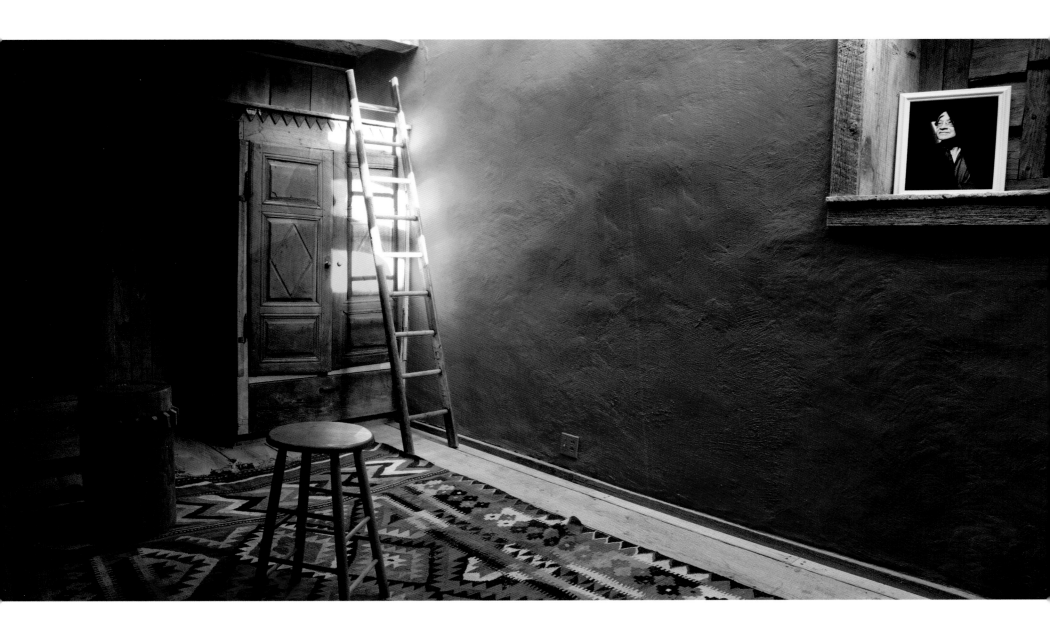

DERRICK C. BROWN

How to Sweep a Floor With Your Whole Body

I got carried until I was shallow in the mud.
Pressed face-first into the dam.
Sad water. Sad water
don't ever make it to the sea.
The best song
is always
far from the hit.
She can love me lame from far away.
She could not love me over laundry,
oil changes and weed whacking.
She missed being nude with me
in a hotel challenging the sea.
It's not the real me. I'm often nothing nights.
I'm often nothing as night.
I don't trust anyone who tells it like it is
when all we really do is rework how it was.
I can't believe you are gone.

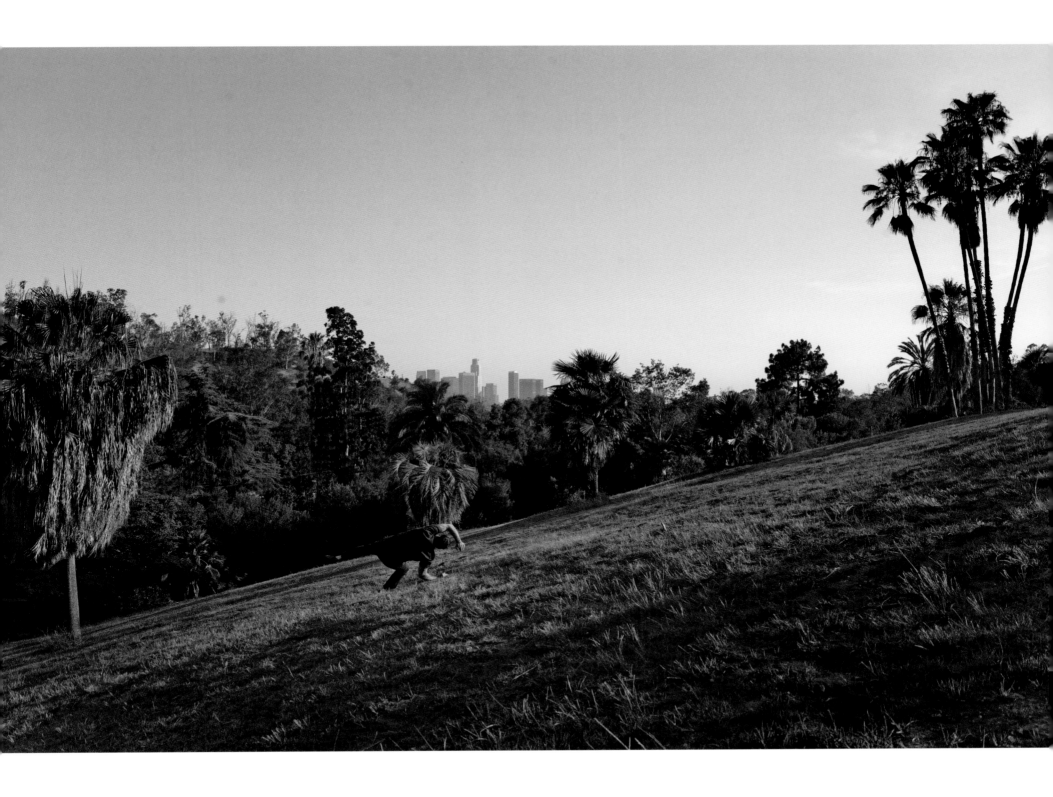

FAITH SHEARIN

The Sound Of A Train

Even now, I hear one and I long to leave
without a suitcase or a plan; I want to step
onto the platform and reach for
the porter's hand and buy a ticket
to some other life; I want to sit
in the big seats and watch fields
turn into rivers or cities. I want to eat
cake on the dining car's
unsteady tablecloths, to sleep
while whole seasons
slip by. I want to be a passenger
again: a person who hears the name
of a place and stands up, a person
who steps into the steam of arrival.

FATIMAH ASGHAR

My Love For Nature

All this tall grass has ruined my gold
acrylic nails & I know something's dead
just beyond my window. I grew up
with rats running my floorboards
& know the smell straining from a body
once caught in a trap. In the city
what little I have of an ass
is always out, a simple wind blow
from *Marilyn Monroe*-ing the street.

I promised myself I'd be naked,
here, in all this nature, but the first day
I found a tick clinging to my arm hair for dear
life & decided no way I'm exposing
my pussy to the elements. My love
for the nature is like my love for most things:
fickle & theoretica. Too many bugs
& I want a divorce

My love for the past is like my love
for most things. I only feel it when
I leave. Last week, before I was here
my uncle drove me from our city
to the suburbs & sang "Project Chick"
in the car. When we parked
he asked me to take off my shoes

& there we walked, silent, barefoot
circling the lake, trying to not step
in goose shit.

He walked in front & I trailed behind
both our hands clasped behind our backs.
He said:

> *When you were my daughter,*
> *those were the happiest days of my life.*
> *I wish you would come home.*

Best to stay gone so I'm always in love.
My gold nails are fake. The floorboards
carry death. My bare feet skirt the shit.

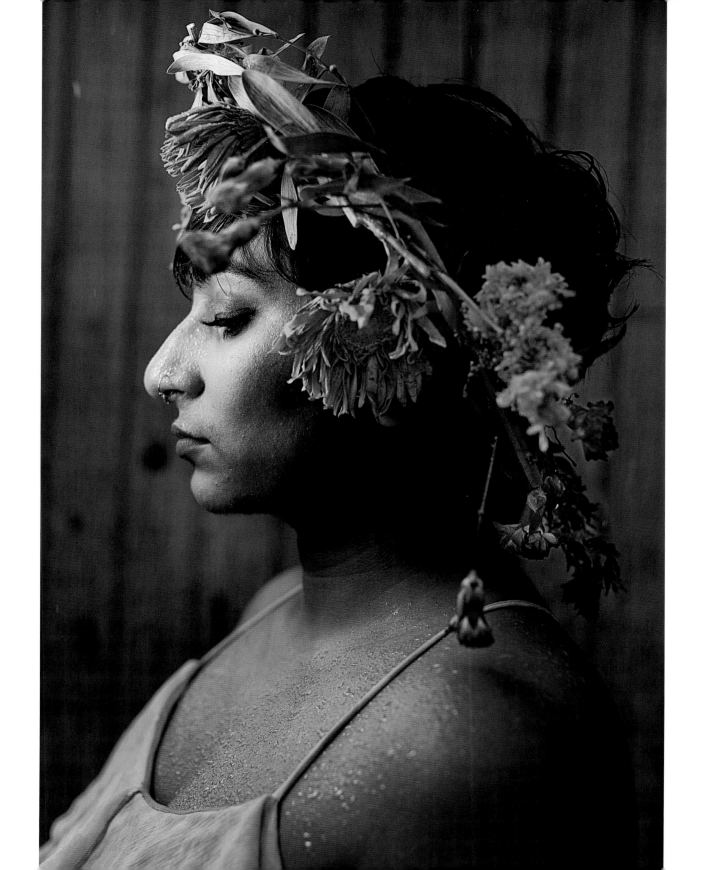

HIEU MINH NGUYEN

Elegy For The First

Our family never understood why you never married
 why you didn't have children.
Mother, going on & on about her friends at bingo
who could've used a man like you
 around the house.
I ask her about the man in the front row—
 the *roommate*, she says. Instead
of the diagnosis, instead of explaining
how or why, isn't it enough to say:
 no more? Who has time
for better dreams than these? Pray for a miracle
or a good night's sleep, won't you? Pray
 for the right ghosts to walk you
to the end of each season.
 Uncle, a story before you sleep:
here, a child dressed in dust.
 This time you wait for him
before you leave. Here, another:
once, I ran, face first, into a mirror
 shattering it, because I didn't recognize
my reflection, because I didn't see a reflection at all.
 I feel each shard opening me
as I walk toward you & that man, now standing beside
 your open casket. He is there
 in every photograph
of you smiling. I want to kiss him.
 I want to take him into me, soften his body
 with my heat & inherit
any pulse you might've left behind. *I'm sorry*
 for your loss, I say, or he says
 or neither of us say, I'm not sure.
I have so many questions. I trace
 your mouth counterclockwise
but you do not answer.

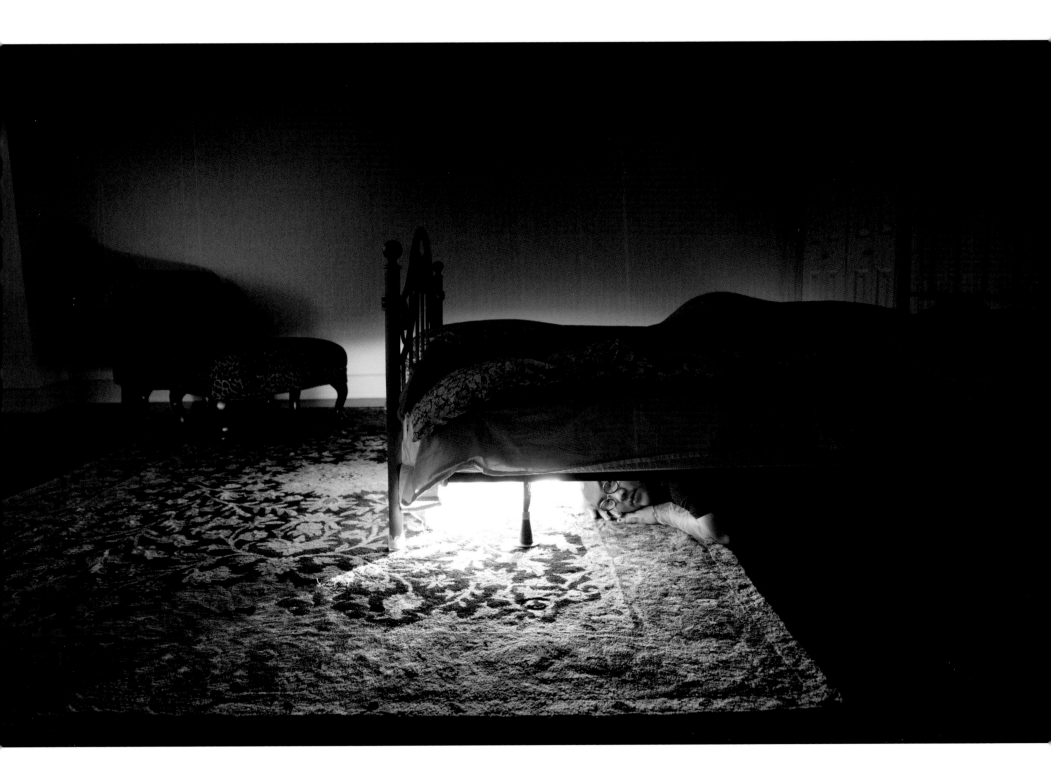

MEG DAY

Elegy In Translation

I was trying to wave to you but you wouldn't wave back
-The Be Good Tanyas

Forgive me my deafness now for your name on others' lips:
each mouth gathers then opens & I search for the wave

the fluke of their tongues should make with the blow
of your name in that mild darkness I recognize but cannot

explain as the same oblivious blue of *Hold the conch to your ear*
& hearing the highway loud & clear. My hands are bloated

with the name signs of my kin who have waited for water
to reach their ears. Or oil; grease from a fox with the gall

of a hare, bear fat melted in hot piss, peach kernels fried
in hog lard & tucked along the cavum for a cure; a sharp stick

even, a jagged rock; anything to wedge down deep to the drum
inside that kept them walking away from wives—old

or otherwise—& the tales they tell about our being too broken
for their bearing, & yet they bear on. Down. Forgive me

my deafness for my own sound, how I mistook it for a wound
you could heal. Forgive me the places your wasted words

could have saved us from going had I heard you with my hands.
I saw Joni live & still thought *a gay pair of guys put up a parking lot.*

How could I have known *You are worthless* sounds like *Should we
do this*, even with the lights on. You let me say Yes. So what

if Johnny Nash *can see clearly now Lorraine is gone*—I only wanted
to hear the sea. The audiologist asks *Does it seem like you're under*

water? & I think only of your name. I thought it was *you*
after **I love**, but memory proves nothing save my certainty—

the chapped round of your mouth was the same shape while at rest
or in thought or blowing smoke, & all three make a similar sound:

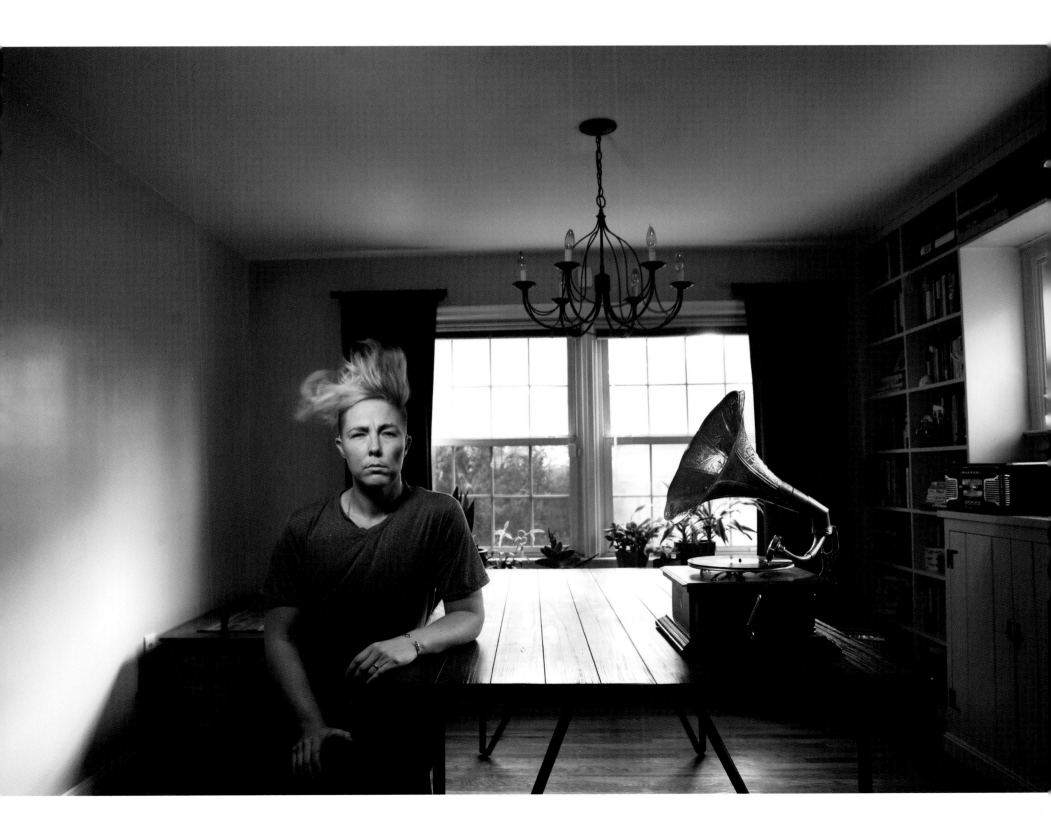

VIJAY SESHADRI

The Disappearances
"Where was it one first heard of the truth?"

On a day like any other day,
like "yesterday or centuries before,"
in a town with the one remembered street,
shaded by the buckeye and the sycamore—
the street long and true as a theorem,
the day like yesterday or the day before,
the street you walked down centuries before—
the story the same as the others flooding in
from the cardinal points is
turning to take a good look at you.
Every creature, intelligent or not, has disappeared—
the humans, phosphorescent,
the duplicating pets, the guppies and spaniels,
the Woolworth's turtle that cost forty-nine cents
(with the soiled price tag half-peeled on its shell)—
but, from the look of things, it only just happened.
The wheels of the upside-down tricycle are spinning.
The swings are empty but swinging.
And the shadow is still there, and there
is the object that made it,
riding the proximate atmosphere,
oblong and illustrious above
the dispeopled bedroom community,
venting the memories of those it took,
their corrosive human element.
This is what you have to walk through to escape,
transparent but alive as coal dust.
This is what you have to hack through,
bamboo-tough and thickly clustered.

The myths are somewhere else, but here are the meanings,
and you have to breathe them in
until they burn your throat
and peck at your brain with their intoxicated teeth.
This is you as seen by them, from the corner of an eye
(was that the way you were always seen?).
This is you when the President died
(the day is brilliant and cold).
This is you poking a ground wasps' nest.
This is you at the doorway, unobserved,
while your aunts and uncles keen over the body.
This is your first river, your first planetarium, your first Popsicle.
The cold and brilliant day in six-color prints—
but the people on the screen are black and white.
Your friend's mother is saying,
Hush, children! Don't you understand history is being made?
You do, and you still do. Made and made again.
This is you as seen by them, and them as seen by you,
and you as seen by you, in five dimensions,
in seven, in three again, then two,
then reduced to a dimensionless point
in a universe where the only constant is the speed of light.
This is you at the speed of light.

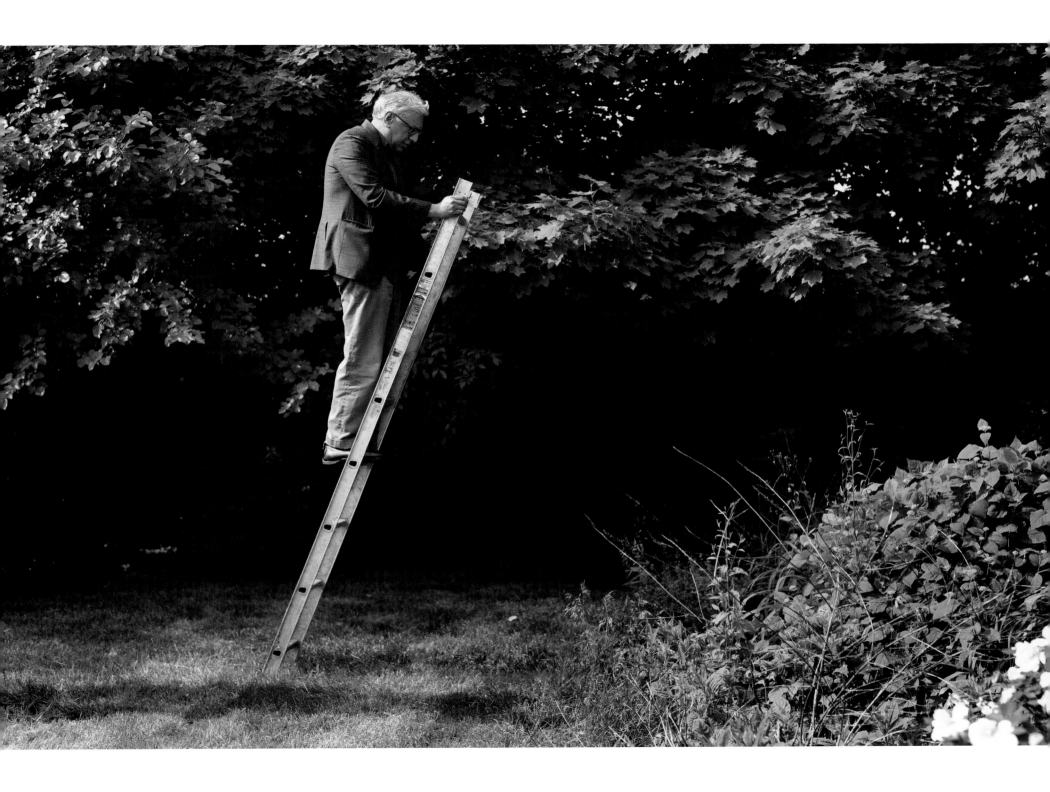

BETH ANN FENNELLY

from Reduced Sentences

I Come from a Long Line of Modest Achievers
I'm fond of recalling how my mother is fond of recalling how my great-grandfather was
the very first person to walk across the Brooklyn Bridge on the second day.

Married Love, 2
There will come a day—let it be many years from now—when our kids realize no
married couple ever needed to retreat at high noon behind their locked bedroom door to
discuss taxes.

Why I'm Switching Salons
"We can put on a topcoat with glitter," said the manicurist. "We all know how how you feel about glitter."

Married Love, 3
As we lower onto the December-cold pleather seats of the minivan, we knock hands:
both of us reaching to turn on the other's seat warmer first.

Returning from Spring Break, Junior Year at Notre Dame
Swapped the rosary on my bedpost for Mardi Gras beads.

Married Love, 4
Bought a bag of frozen peas to numb my husband's sore testicles after his vasectomy.
That night I cooked pea soup.

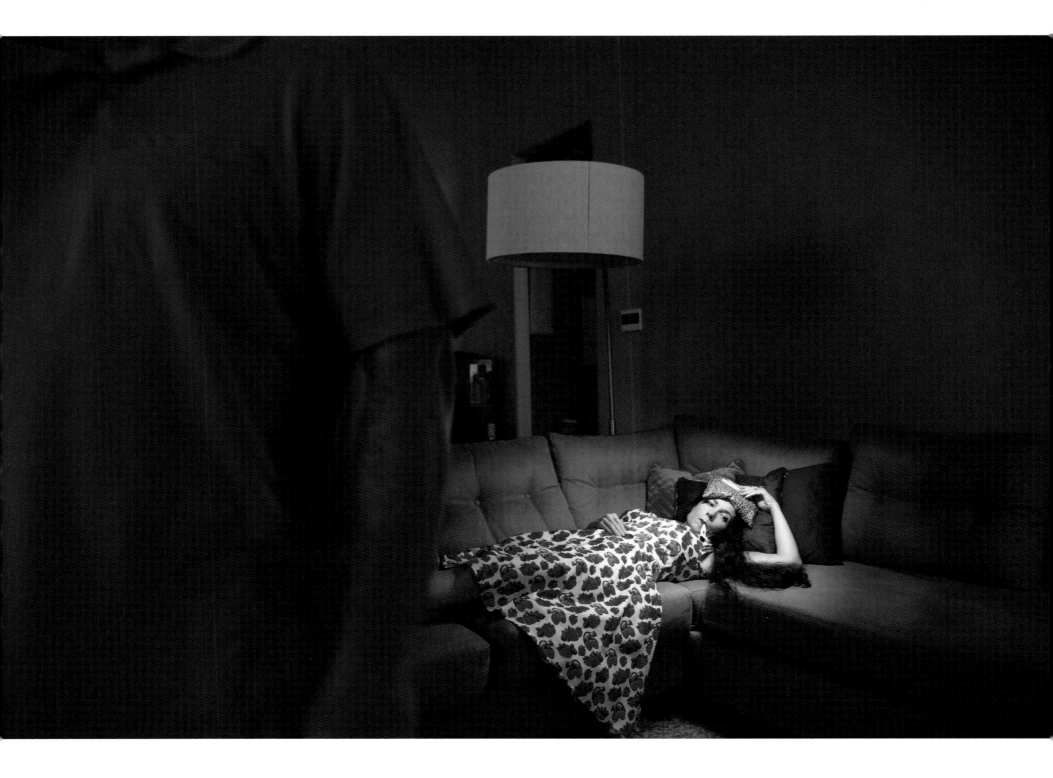

BRYAN BORLAND

Summer In America

It's summer in America and no one knows
how high to fly their flag
 or which flag to fly
for our part we have again pledged allegiance
to one another but this isn't a love poem
there are no love poems in America today
only the poetry of necessity of documentation
written at a time when we can make no promises
of life in twenty years or less than that
if our skin is brown or black look back
that same number of years to what the poets
were trying to tell us and who listened
and why we didn't look at the revolutions
that begin when we remember to point
the camera outside ourselves the enemy
of our enemy is our enemy is what they
teach us but what does that camera catch
: the murder in front of our smiling faces
the blood splatter on our shirts
they tried to tell us was decoration

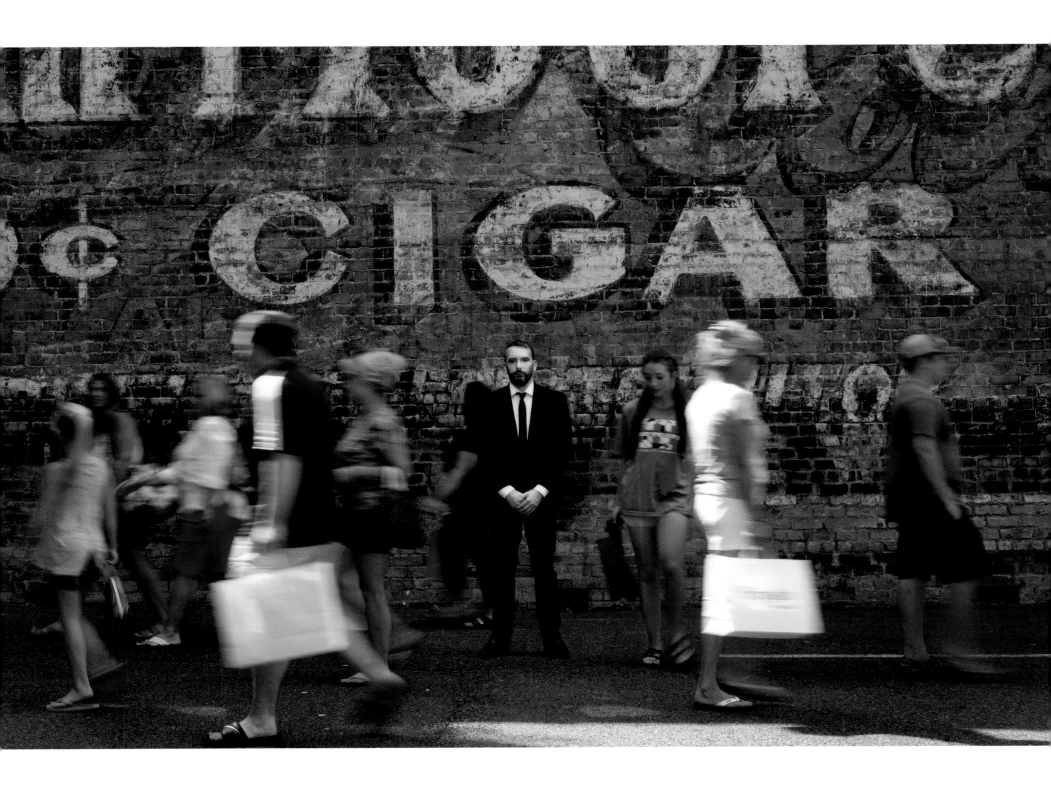

JOYCE CAROL OATES

Women Whose Lives are Food, Men Whose Lives are Money

Mid-morning Monday she is staring
peaceful as the rain in that shallow back yard
she wears flannel bedroom slippers
she is sipping coffee
she is thinking—
 —gazing at the weedy bumpy yard
at the faces beginning to take shape
in the wavy mud
in the linoleum
where floorboards assert themselves

Women whose lives are food
breaking eggs with care
scraping garbage from the plates
unpacking groceries hand over hand

Wednesday evening: he takes the cans out front
tough plastic with detachable lids
Thursday morning: the garbage truck whining at 7
Friday the shopping mall open till 9
bags of groceries unpacked
hand over certain hand

Men whose lives are money
time-and-a-half Saturdays
the lunchbag folded with care and brought back
 home
unfolded Monday morning

Women whose lives are food
because they are not punch-carded

because they are unclocked
sighing glad to be alone
staring into the yard, mid-morning
mid-week
by mid-afternoon everything is forgotten

There are long evenings
panel discussions on abortions, fashions,
 meaningful work
there are love scenes where people mouth passions
sprightly, handsome, silly, manic
in close-ups revealed ageless
the women whose lives are food
the men whose lives are money

fidget as these strangers embrace and weep and
 misunderstand and forgive and die and weep
 and embrace
and the viewers stare and fidget and sigh and
begin yawning around 10:30
never made it past midnight, even on Saturdays,
watching their braven selves perform

Where are the promised revelations?
Why have they been shown so many times?
Long-limbed children a thousand miles to the
 west
hitch-hiking in spring, burnt bronze in summer
thumbs nagging
eyes pleading
Give us a ride, huh? Give us a ride?

and when they return nothing is changed
the linoleum looks older
the Hawaiian Chicken is new
the girls wash their hair more often
the boys skip over the puddles
in the GM parking lot
no one eyes them with envy

their mothers stoop
the oven doors settle with a thump
the dishes are rinsed and stacked and
by mid-morning the house is quiet
it is raining out back
or not raining
the relief of emptiness rains
simple, terrible, routine
at peace

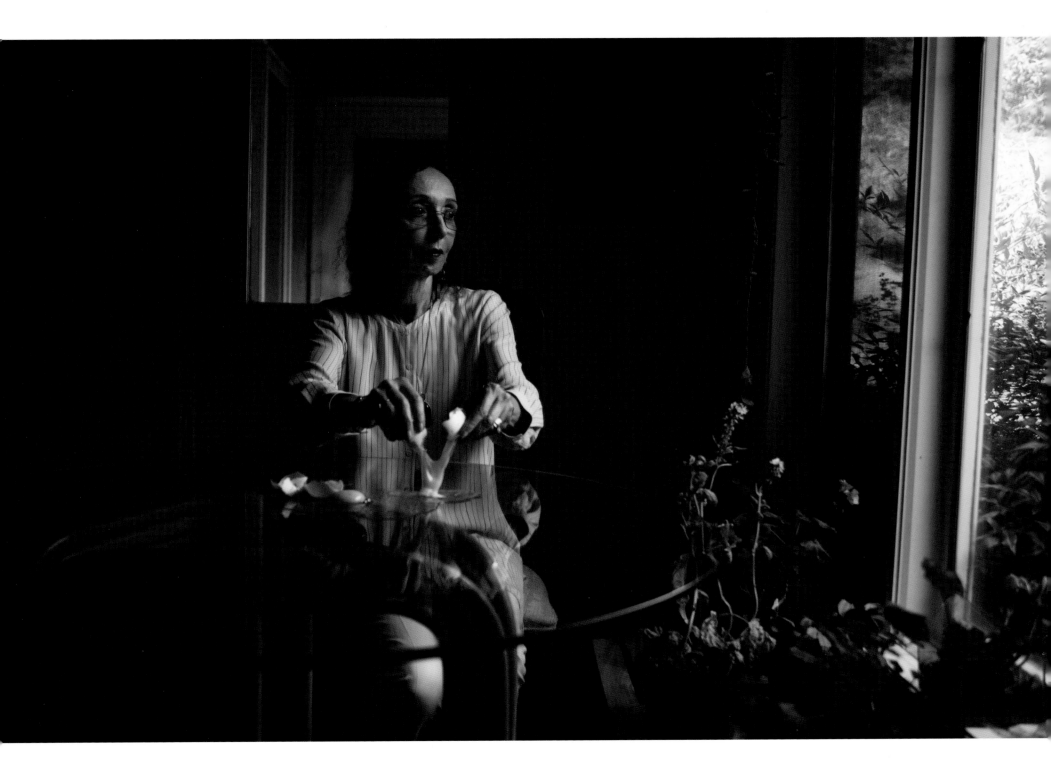

MARTY MCCONNELL

Meet Me At The End Of The World—I'll Be The One In Sequins

You seem the sort who'll survive. Whose grandfather built a bomb shelter
in the 50s and remembered to include a can opener. It's not bombs
that end us, but shelter is nonetheless essential. The light
will be that heroic twilight light that makes everything
look like a movie, like the best movie you've ever seen is just
beginning, the light that reminds you it's nearly time to come
inside, your mother waiting in an apron or the suitcase
packed or good wine chilling and the radiator beginning
to clink. Bring your instrument. While I'm waiting
I'll go over the less sad songs I have by heart.
What we did to get here is gone now, let's not talk
about it anymore. We may not need
to talk at all. You'll know me by how the light strikes
the sequins. I'll practice the cruel songs too, lying here
in the passing light. Studying the leaves
on the topmost branches on the tree at the end
of the world. We know what we did
to get here. We're still living in these mouths.

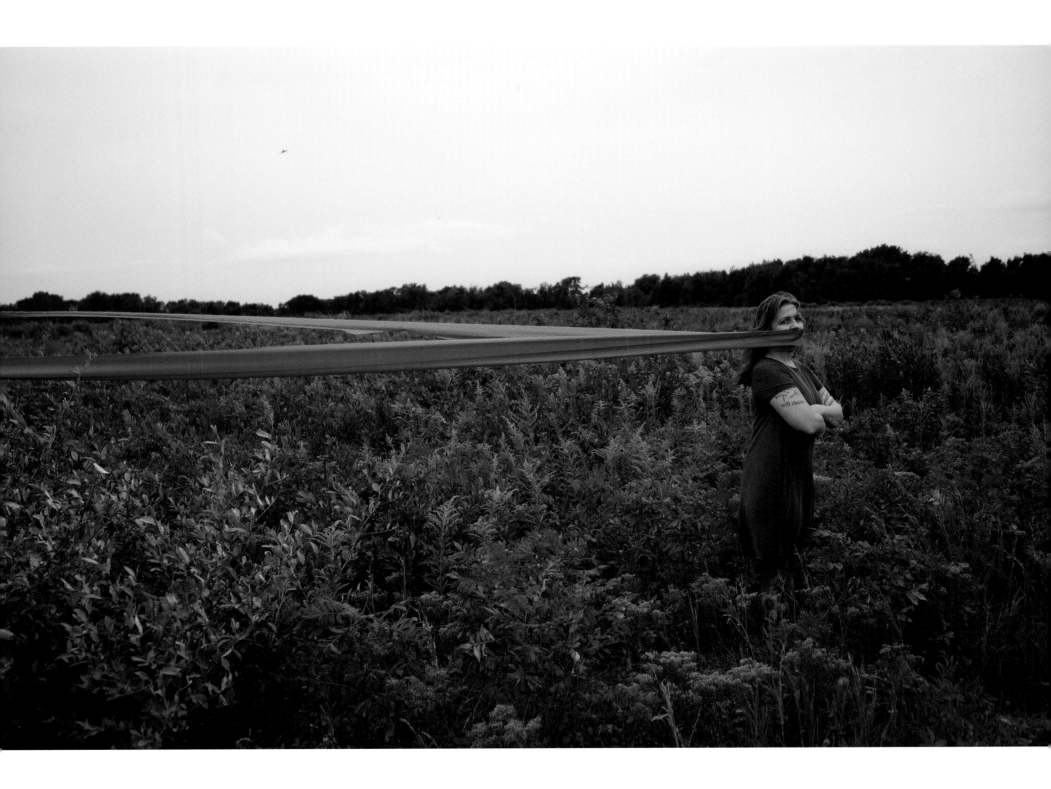

LEE ANN DALTON

Preface To A Long Marriage

Lately, I've gone running after dark
to soften stone walls. Barbed wire disappears,
old plow-handles rise to dusky arcs
like wings of a flightless bird riled up by fear,
his silent threat displayed until I pass,
hear him trill under his breath, It's come down to this.
And now, I'm only angry with myself
for holding back. I swallow my words alive
but they rise up into my mouth, sticky with regret,
rehearsing daylight's ruin. A red-tail dives
past my head, screaming here, here—feed yourself
here. No one's looking to hurt you anymore.
And then tonight, when I stumbled back home,
wrung out and thirsty, encrusted in salt, a light
shone from the porch, held him in relief—dear
man, the reason there's still something right
after all. I kissed his open hands.

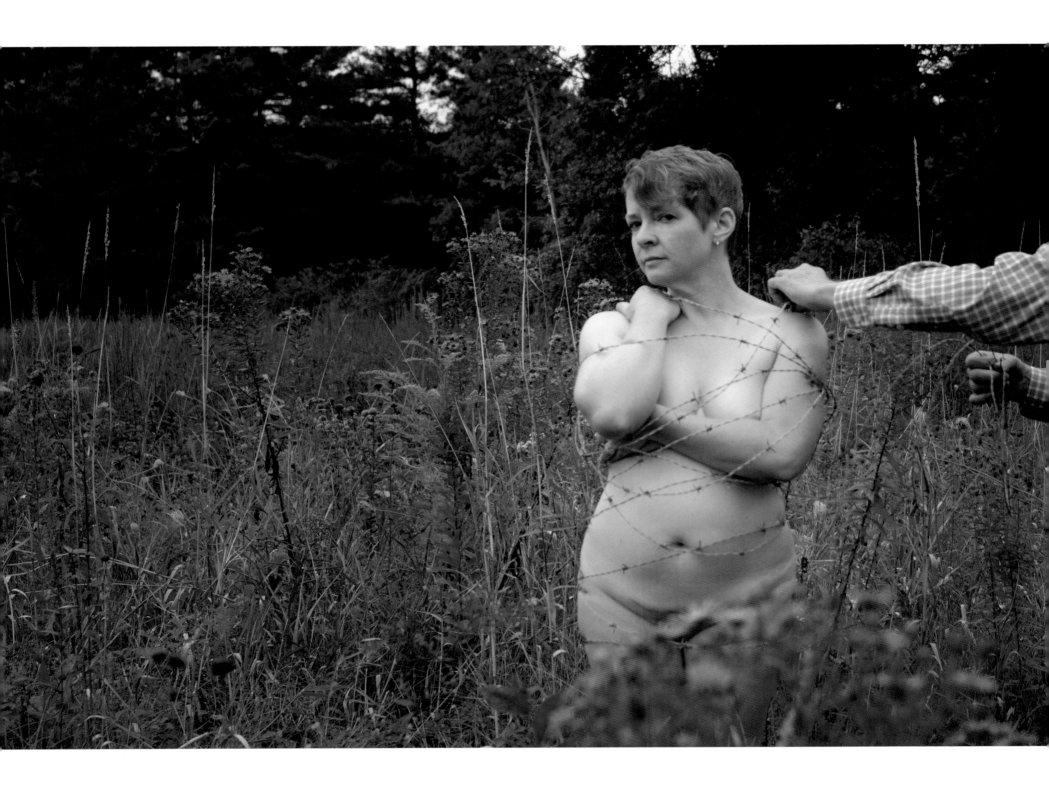

LESLIE ANNE MCILROY

On the Rocks

I love my son so much
I no longer call him my daughter.
He presses his bound breasts to me
when I hug him hello and goodbye.
He wants them gone.
I want him safe.
I show him how to draw back
the testosterone in the syringe.
Years as a diabetic
make me an expert.
I never wanted a son and now
I want him more than ever.
Water and ice are the same
thing, right? It's just that
one is harder than the other.

DUNYA MIKHAIL

من أ لواح *from TABLES*

الشيء الغريب
أنَكَ في الحلم
كنتَ حلماً ا أيضاً

So strange,
in my dream of us,
you were also a dream.

أغمُض عيني فأرى نقطة
تُصبحُ بقعَة ضوء
تكبرُ بحجم شخص
يبتعُد
حتى يصبحَ بقعة ضوء
نقطة

I close my eyes and I see a dot.
It becomes a spot of light.
It grows into the size of a person
who distances away
until it returns to a spot of light,
a dot.

وقعتُ في حفرة في منامي
وعندما صحوتُ
وجدتُ ريشة .
ول اني وضعتُها تحت وسادتي
قبل أن أنام
لحلمتُ أني بأبة حرامة
ومرا كنتُ وقعتُ في الحفرة .

I dreamt I fell into a hole
and when I woke
I found a feather.
If only I'd put it under my pillow
before going to sleep:
I'd have dreamt I was a dove
and wouldn't have fallen.

BUDDY WAKEFIELD

Print Flocking

He wrote to you with firecracker chalk
on a blackboard background

from a free-standing landing pad
held together by choir claps

over buttercups spraying
out the mouths of doves.

Getting to his point
would require starting over

at the outer loop
of your ripple effect

swinging monkey bar style
arm over arm

parallel to parallel
minding the gaps.

Sometimes it takes a deeper breath
to hover on holy

against the current.
back to where the rock dropped

He wasn't falling out of love with you.
He was falling out of ways to get there

TYLER KNOTT GREGSON

Bring me a cut man, steady hands
still quick with stitch and sew.
I'm bruised and sliced
and these will scar.
Sit me on the stool,
sponge water til the red
runs clear,
I will stand again,
I will always get back up.
Wipe these eyes of the blood
that pooled,
I need to see
what's coming for me.
I will haunch over and gasp
for breath, I will
rise steady and slow,
I will shrug the blows absorbed,
and walking forward,
I will grin.

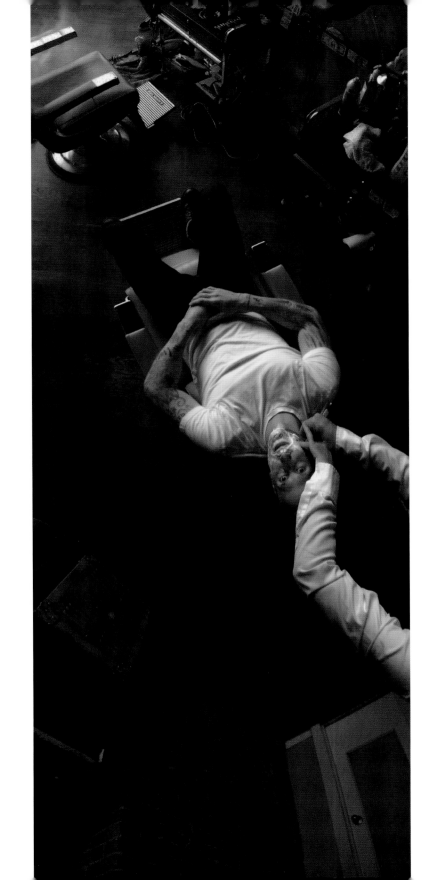

MATTHEW ZAPRUDER

Lamp Day

All day I've felt today is a holiday,
but the calendar is blank.
Maybe it's Lamp Day. There is
one very small one I love
so much I have taken it everywhere,
even with its loose switch.
On its porcelain shade are painted
tiny red flowers, clearly
by someone whose careful
hand we will never know.
Because it's Lamp Day I'm trying
to remember where I got it,
maybe it was waiting for me
in the house on Summer Street
I moved into almost exactly
17 years ago. I think
without thinking I just picked it
up from the floor and put it
on my desk and plugged
it into the socket and already
I was working. So much
since that moment has happened.
On Lamp Day we try
not dreamily but systematically
to remember it all. I do it
by thinking about the hidden
reasons I love something
small. When you take
a series of careful steps
to solve a complex problem,
mathematicians call it an algorithm.
It's like moving through

a series of rooms, each with
two doors, you must choose one,
you can't go back. I begin
by sitting on a bench in the sun
on September 21st thinking
all the walks I have taken
in all the cities I have chosen
to live in or visit with loved ones
and alone make a sunlit
and rainy map no one
will ever be able to hold.
Is this important? Yes and no.
Now I am staring
at clean metal girders.
People keep walking past
a hotel, its bright
glass calmly reflecting
everything bad and good.
Blue boots. Bright glass.
Guests in this moment. A child
through the puddles steps
exuberant, clearly feeling the power.
I am plugged in. I am calm.
Lamp Day has a name.
Just like this cup
that has somehow drifted
into my life, and towards which
sometimes for its own reasons
my hand drifts in turn.
Upon it is written the single
word Omaha.

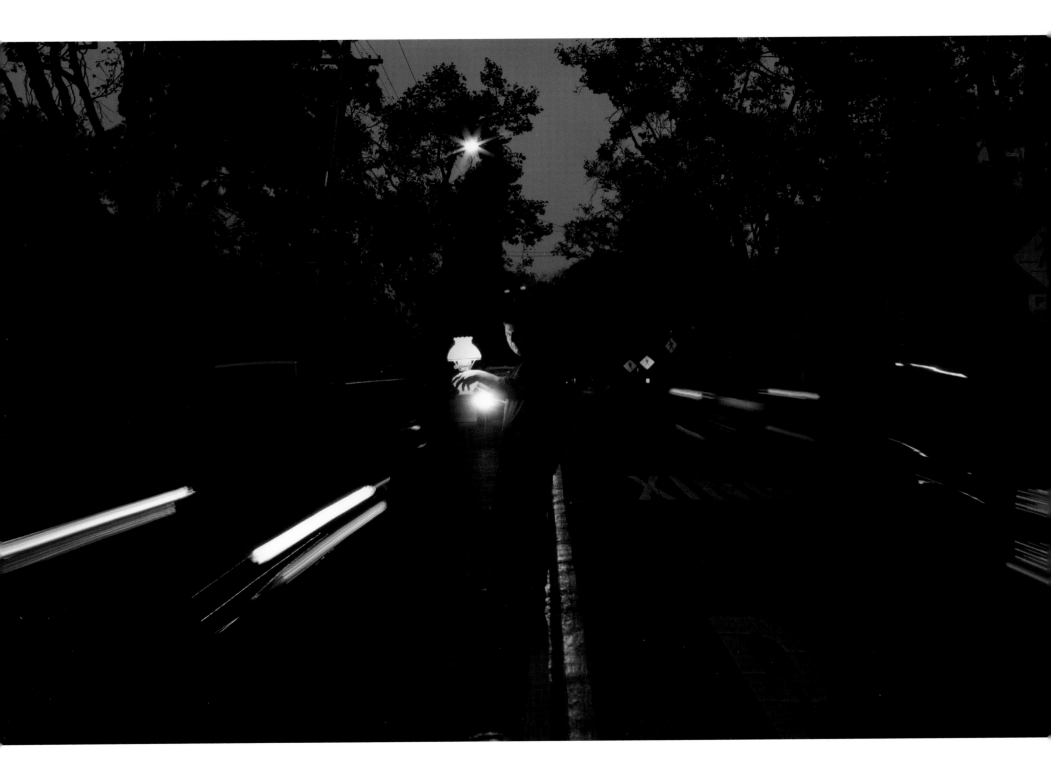

YUSEF KOMUNYAKAA

Facing It

My black face fades,
hiding inside the black granite.
I said I wouldn't
dammit: No tears.
I'm stone. I'm flesh.
My clouded reflection eyes me
like a bird of prey, the profile of night
slanted against morning. I turn
this way—the stone lets me go.
I turn that way—I'm inside
the Vietnam Veterans Memorial
again, depending on the light
to make a difference.
I go down the 58,022 names,
half-expecting to find
my own in letters like smoke.
I touch the name Andrew Johnson ;
I see the booby trap's white flash.
Names shimmer on a woman's blouse
but when she walks away
the names stay on the wall.
Brushstrokes flash, a red bird's
wings cutting across my stare.
The sky. A plane in the sky.

A white vet's image floats
closer to me, then his pale eyes
look through mine. I'm a window.
He's lost his right arm
inside the stone. In the black mirror
a woman's trying to erase names:
No, she's brushing a boy's hair.

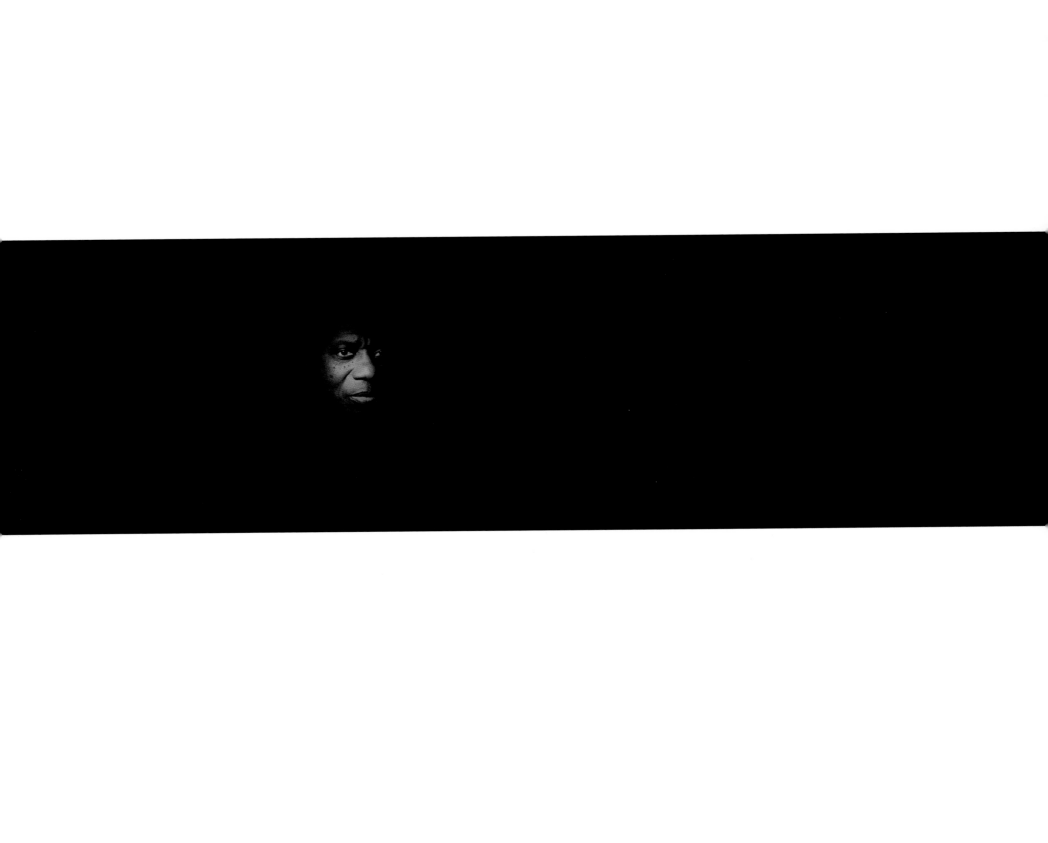

JOSEPH O. LEGASPI

Imago

As soon as we became men
my brother and I wore skirts.
We pinched our skirt-fronts into tents
for our newly-circumcised penises, the incisions
prone to stick painfully to our clothing.

I was partial to my sister's plaid skirt,
a school uniform she outgrew; my brother favored
one belonging to my grandmother, flowers
showering down his ankles.
By this stage, the skin around the tips
of our penises was swollen the size
of dwarf tomatoes.

As a cure, my mother boiled
young offshoots of guava leaves.
Behind the streamline of hung fabric,
I sat on a stool and spread

before a tin washbasin. My mother bathed
my penis with the warm broth,
the water trickling into the basin like soft rain on our roof.
She cradled my organ, dried it with cotton,
wiping off the scabs melted by the warmth,
and she wrapped it in gauze, a cocoon
around my caterpillar sex.

I then thought of the others at the verge of their manhood:
my brother to replace me on this stool,
a neighborhood of eleven-, twelve-, and thirteen-year old
boys wearing the skirts of their sisters
and grandmothers, touched
by the hands of their mothers,
baptized by green waters,
and how by week's end
we will shed our billowy skirts,
like monarchs, and enter
the gardens of our lives.

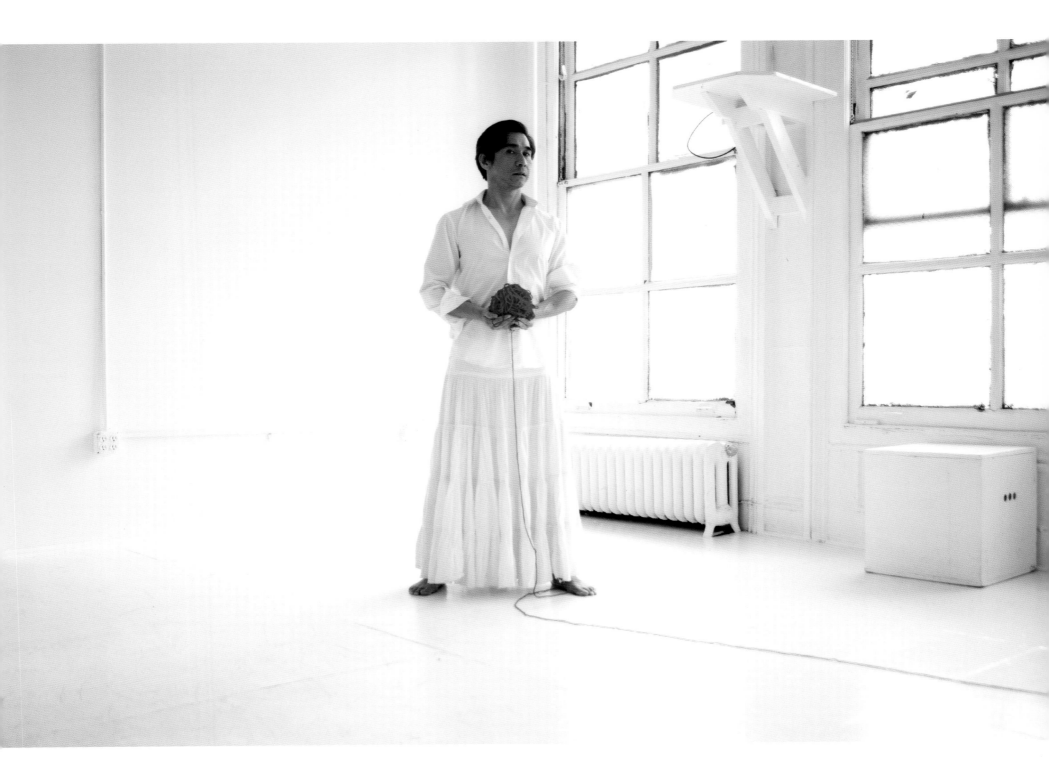

ALICIA OSTRIKER

Vocation

To play among the words like one of them,
Lit from within—others can see it,
Never oneself—

She slips like a cat through traffic,
A girl alone downtown
For the first time, subway fare in her purse,

Fear of losing it
Clamping her chest,
Wind whipping tears from her eyes,

Fried grease and gasoline in her nose, shoes and
Jewelry in shopwindows. a spike
Of freedom stitching her scalp—

Though she dreads the allergy shot at the clinic
She feels herself getting brave.
Now it begins to snow on Central Park South

And a flight of pigeons
Whim up from a small pile of junk in the gutter
Grey, violet, green, a predatory shimmer.

The marquee of the Paris Theater
Looks at the rapturous child
Through downcast lashes, condescendingly.

I watch her over a distance of fifty years.
I see how small she is in her thin coat.
I offer a necklace of tears, orgasms, words.

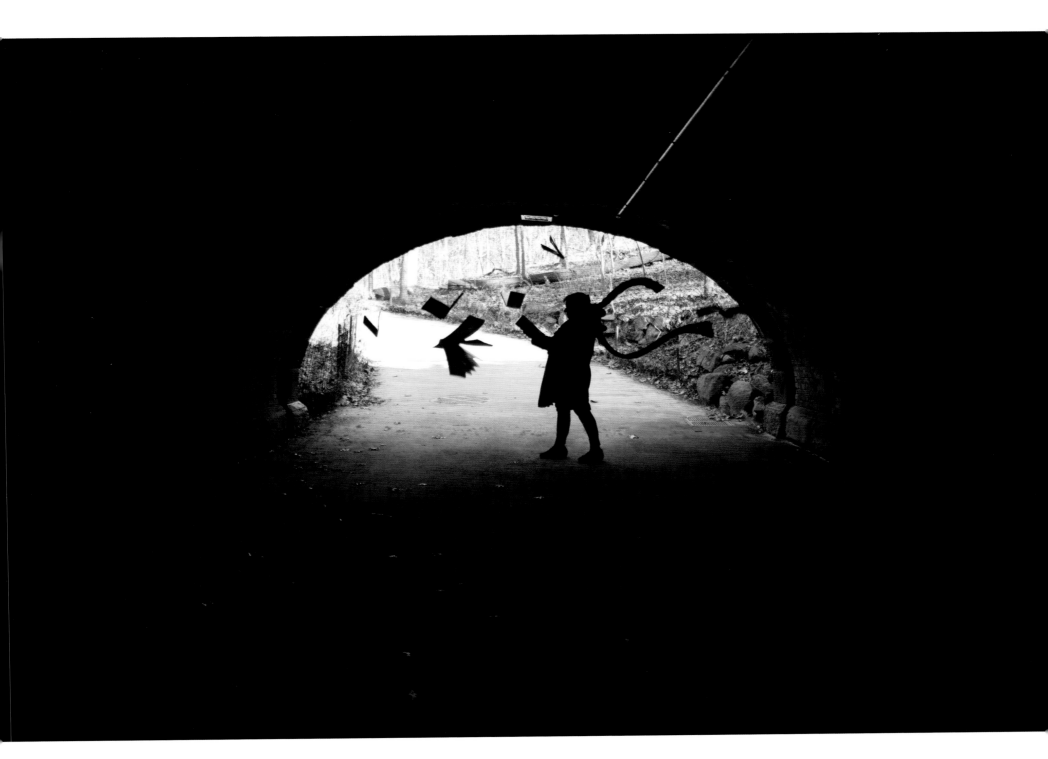

BRENDAN CONSTANTINE

Lecture on Thomas Edison

In 1887 Thomas Edison began electrocuting dogs
for the press. He called it his duty to warn us
against the "evil" of Alternating Current,
a power he failed to discover first.

 It was not killing,
he told a reporter, the dogs had been
Westinghoused.

 When he was twelve, Edison lost half
his hearing. No one knew how, but there were many
theories; one that he was pulled aboard a train
by his ears. Another, that he repeatedly forced coins
into them to attract lightning.

 There were cats, too,
& birds when he could get the electrodes to fit. Once,
he even wired a sunflower which opened like an eye
to weep out its seeds.

 From his crib, Edison
routinely blew out his beside candles, howling until
they were relit. On several mornings, his mother
woke to find a half-eaten stub dried to the infant's
gown.

 In 1903 he ran 6,000 Volts through an elephant
named Topsy. She had killed three men, the last a drunk
who gave her a cigarette. Edison filmed her execution
to play for whomever might ask.

 Upon hearing
his own voice through a phonograph, he exclaimed *I am
always afraid of things that work the first time.*

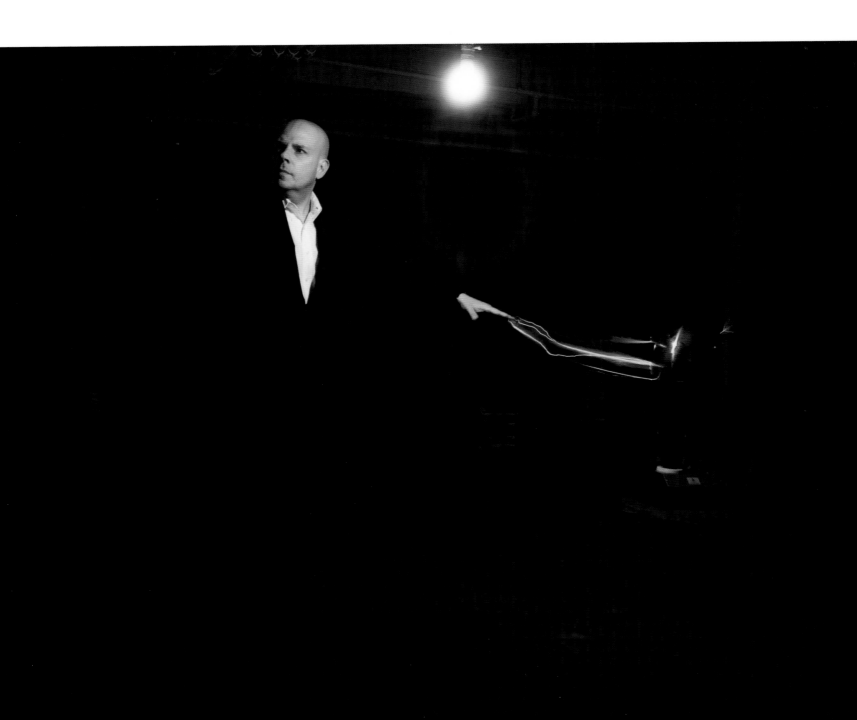

TAYLOR MALI

Undivided Attention

A grand piano wrapped in quilted pads by movers,
tied up with canvas straps—like classical music's
birthday gift to the criminally insane—
is gently nudged without its legs
out an eighth-floor window on 62nd street.

It dangles in April air from the neck of the movers' crane,
Chopin--shiny black lacquer squares
and dirty white crisscross patterns hanging like the second-to-last
note of a concerto played on the edge of the seat,
the edge of tears, the edge of eight stories up going over—
it's a piano being pushed out of a window
and lowered down onto a flatbed truck!— and
I'm trying to teach math in the building across the street.

Who can teach when there are such lessons to be learned?
All the greatest common factors are delivered by
long-necked cranes and flatbed trucks
or come through everything, even air.
Like snow.

See, snow falls for the first time every year, and every year
my students rush to the window
as if snow were more interesting than math,
which, of course, it is.

So please.

Let me teach like a Steinway,
spinning slowly in April air,
so almost--falling, so hinderingly
dangling from the neck of the movers' crane.
So on the edge of losing everything.

Let me teach like the first snow, falling.

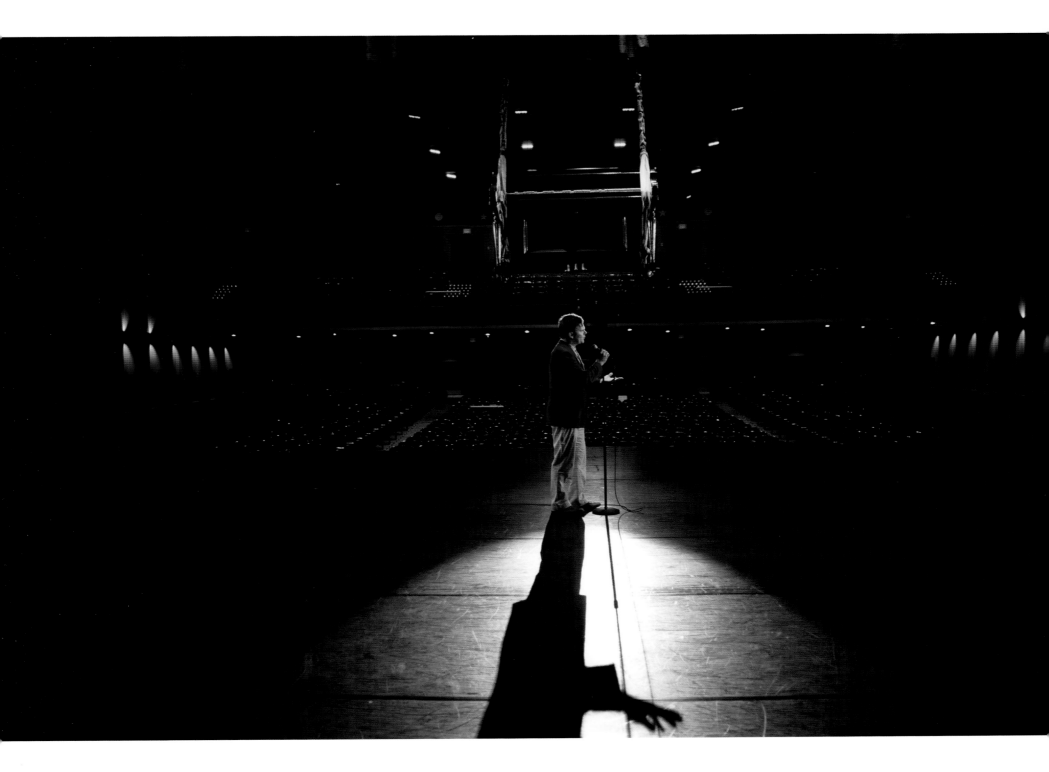

AFTERWORD

B.A. Van Sise

POETRY IS THIS CONTINENT'S ORIGINAL LANGUAGE, present here since the times when humans could arrive from Asia by walking. Long before ink appeared on our shores, poetry was used by repetition and rote to pass stories from mothers and fathers to daughters and sons, generation after generation, evolved and elaborated by every telling.

Poetry is as at home in this new world as grass.

America is a land of grass. Some of it is of local breeding—go west, young man, and find the plains and the brush and the mountaintop tufts— but much of it was imported millennia after the first settlers by new peoples who brought horses, guns, smallpox, and an alphabet. Those immigrants augmented the ancient plains, over time, with streets and houses and manicured yards, their lawns filled with endless growing imported grasses, weeding up at every inch, non-native breeds planned and planted to be pretty and perfect: the continent has changed, and so has the use of language that has, since our beginning here, defined it.

I began this work after a difficult surgical procedure that had left me in abyss. Rutted in my life—in my heart, in my health, and in my work—I hoped to lift my spirits with a little pet project, setting out on what I now realize was actually an ambitious mission: to make a portrait of American poetry. I decided to make visual poems of the many contemporary poets working today, to present the poets themselves in conversation around and within their work: *may your very flesh become a great poem*. I'd planned to photograph 15 of America's most notable poets, and it turned out that 15 people looks about the same as no people at all. A few months later, when finally able to walk, breathe, and live my love again, the 15 poets I'd photographed began to stretch to 25, and then 40, and by the time it had reached 80, I knew what had already been obvious to many others: the poets hadn't just found me. They'd saved me.

Other than nothing, a photograph is the least you can let someone take of you. It is an infinitesimal fraction of a second, in a life with millions of them. At its core, a photograph is not the person; like a poem, it is the reflection of that person's light.

Photographs, like poems, suffer the same misconception and benefit from the same delusion: they are the only two art forms that are expected to be honest, and they are, perhaps, the two that most often mislead. If poetry's most lasting value is empathy, photography's is correspondence: this is the message I've received, and this is the message I send on.

The photographer's supposedly arbitrary selection of light, time, angle, and moment mimics the poet's supposedly arbitrary selection of phrase, thought, form, and emotion. The honest poet, like the honest photographer, lies.

This book is the result of that project and is, in many ways, a census, a sampling. The whole of poetry is not here; there are plenty of poets whose words are not present, whose bodies are not present. Some are absent because there was no time, some because there was no inclination, some because they left the world just a little too early or came to my attention just a little too late. It is important to note that, for the most part, the selection of poets here is self-curated by the poets themselves: while its fundament is a bedrock of universally agreed notables, every poet featured was asked to suggest two others who they felt worthy of inclusion in this anthology. While there are a few diversions, those recommendations were largely heeded as a democratic safeguard against the tyranny of my own tastes.

Democracy, after all, is key when one purports to talk about America. Walt Whitman, to whom I am a distant and no doubt disappointing relative, claimed in his own words that he contained multitudes: descendant of slave-owners, proponent of emancipation, chauvinist in his words and actions, homoerotic in his thoughts and deeds, Barnumesque self-promoter fully devoted to both hucksterish ballyhoo and his true duty as soothsayer of a vivid tapestry of plural America.

The modern nation, like Whitman, contains multitudes; an unsingular society of which antebellum poets could scarcely have imagined.

When Whitman, huge and proud and small and fragile, produced his first edition of *Leaves of Grass* at 36 years old, every prominent American poet was white and northern; today, as I produce *Children of Grass* at the same age, American poetry is a landscape as diverse as the land that gives birth to it, a cacophony of voices from persons of all colors, genders, religions, backgrounds, loves. A significant number of the American poets in this album were, appropriately, not born in America.

And that group, once unimaginable, is also now quite celebrated; the 80 poets featured in these pages have an astonishing array of accolades. There are four Poets Laureate, 13 Pulitzer awardees and nominees, two MacArthur fellows, and a host of other distinctions: six Whiting Awards, three Lannan Fellowships, three Robert Frost medalists, and so many other prizes too monotonous to count, in addition to some 27 Guggenheim fellows and 14 chancellors of the Academy of American Poets.

Leaves of Grass was first published in 1855, in the run-up to a looming, grotesque, and necessary civil war, and now on the 200th anniversary of Whitman's birth we find ourselves in the midst of a looming, grotesque and perhaps necessary cultural one. In a time when cruelty abounds, the act of creating—of making beauty—is revolutionary. There has never been a more important time for the chorus of poetic voice on this continent, for it to be elaborated and evolved by every telling.

This work is meant to be seen, but also to be heard. In the distance, listen closely, with a keen ear, for Walt Whitman, in his tomb, ringing his coffin bell: *I am alive, I am alive, I am alive*, praying to be heard by these sons of America, these daughters of poetry—these children of grass.

ACKNOWLEDGMENTS

THIS IS A KITCHEN WITH MANY COOKS, not least of which the dozens of poets who gave the gift of their time, their patience, and their passion.

A few people deserve special thanks: my father and his father, Gordon W. Van Sise, for their neoteric example and my esoteric marrow; Robin Porter and Kathryn E. LeGrande, for their endless and until now thankless assistance; Vaughan Fielder, Kaveh Akbar, and Corinne Segal for their early support, and Dorianne Laux for telling every poet in North America that I'm the right kind of crazy.

In addition, I must express near-endless gratitude to Rebecca Senf and the Center for Creative Photography, Tyler Meier and the University of Arizona Poetry Center, Leslie Ureña and the National Portrait Gallery, and Schaffner Press for the tremendous depth, assistance, and guidance they've given in making this project possible and visible.

CREDITS

The Publisher gratefully acknowledges the following for their assistance in the research, compiling, and editing of these credits: Tyler Meier and the University of Arizona Poetry Center; Matthew O'Malley; Sean Murphy.

THE AUTHOR

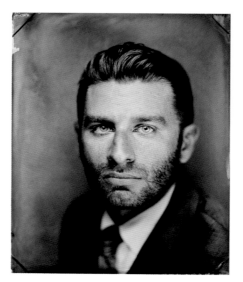

A FREQUENT CONTRIBUTOR TO THE *Village Voice* and *BuzzFeed*, B.A. Van Sise is also one of the world's busiest travel photographers. In addition to being a Nikon/AFAR travel photography ambassador and a travel photography workshop instructor for Atlas Obscura, Van Sise has been a staffer for *Newsday* and *AOL CityGuide*, and his work has been a featured subject on the cover of *The New York Times*, on PBS *NewsHour*, and on *NPR*. A number of his portraits of notable American poets are in the permanent collection of the National Portrait Gallery of the Smithsonian.

His work as both a photographer and author has previously appeared in the *Washington Post*, the *Los Angeles Times*, the *Daily Mirror of London*, and approximately 250 other publications, in addition to exhibitions at the Peabody Essex Museum, the Museum of Jewish Heritage, Center for Creative Photography, and the Whitney Museum of American Art. He is a graduate of the prestigious Eddie Adams Workshop and a National Press Photographer's Association award-winner.

MARY-LOUISE PARKER is a Tony, Emmy, and Golden Globe award-winning actress. Her writing has appeared in *Esquire*, *The Riveter*, *Bust*, and *The Bullet*, and she is the author of the bestselling memoir, *Dear Mr. You*.